# beach huts

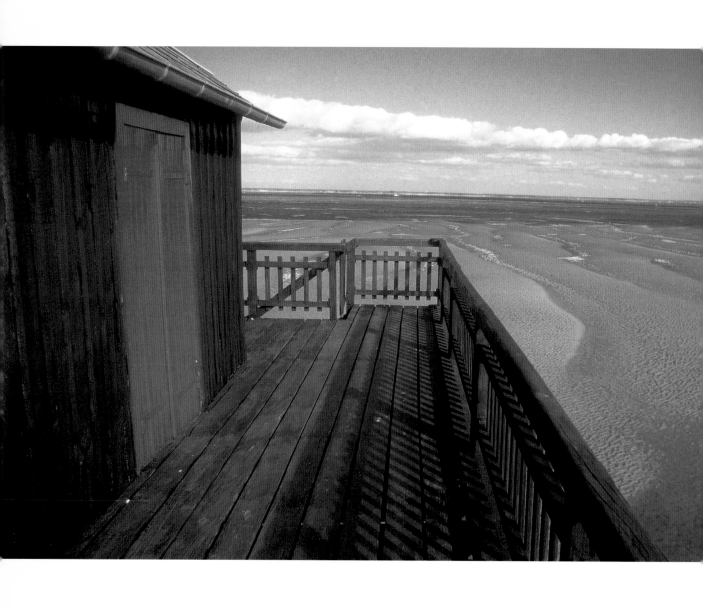

# beach huts

ROD GREEN

CASSELL
ILLUSTRATED

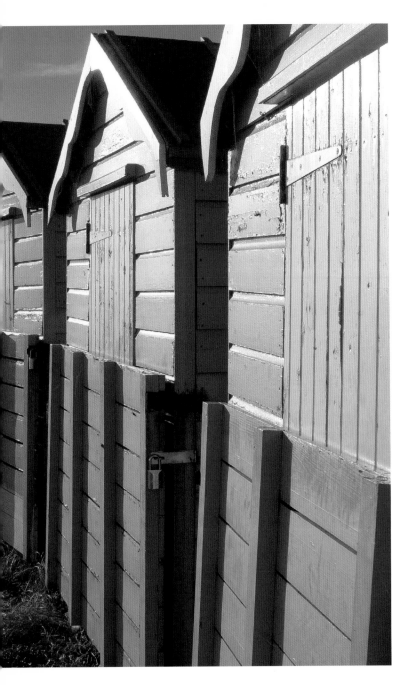

First published in Great Britain in 2005 by Cassell
Illustrated, a division of Octopus Publishing Group
Limited, 2–4 Heron Quays, London E14 4JP.

A CIP catalogue record for this book is available
from the British Library.

ISBN  1844032914
EAN  9 781844 032914

Editor: Joanne Wilson
Design: Design 23

Printed at Toppan, China

Previous page: **Arcachon, Gironde, France.**
Left: **Littlehampton, Sussex.**

# contents

# When you picture your ideal beach scene

in your mind's eye you may well conjure up a picture of a sun-kissed South Pacific shore; a palm-fringed paradise of white sand stretching off into the distance where the cloudless blue sky seems to merge effortlessly with the lazy azure waters of a tropical sea. That is not, however, everyone's idea of a perfect beach. For many, that slender strip of white sand would be swapped for a wide expanse of beach rolling up from the breaking waves into a range of rugged dunes and the curtain of verdant tropical vegetation drawn along the shoreline by nature would be replaced by a barrier fashioned by the hand of man – a gaily painted row of beach huts.

The traditional wooden beach hut 'shack' can trace its history back over 250 years and the simple wooden structures have since become a feature of seaside towns all over the world, from the beaches and promenades around the shores of Britain down through the northern European resorts into Italy, into South Africa and even in Australia, not to mention across the Atlantic to the USA. Although they evolved as a development of the bathing machine, a contraption that was originally the preserve of the most affluent seaside holiday-makers who could afford the substantial fees charged for their use, beach huts became a cheap and cheerful way for the popular masses to enjoy a day at the seaside. Rather than a being a facility patronized by the wealthy social elite, beach huts were used by families holidaying on a restricted budget.

Nowadays, in some resorts, the cost of buying or hiring a beach hut has made them once more an indulgence for those with a large disposable income, the price tag sometimes equivalent to that of a small house. Despite the fact a hut might cost as much as a house, it is still not possible to sleep in most huts. The traditional wooden hut is little more than a garden shed, used for changing into your swimsuit or storing the paraphernalia of a visit to

# INTRODUCTION

the beach – the deck chairs, beach balls, windbreaks, buckets and spades.

But the little wooden hut – the majority of purist hutters will eschew concrete or new-fangled plastic versions – does have far more exotic cousins. Picture that tropical beach scene in your imagination once again. Lurking there amongst the palm trees, perhaps you can just make out a palm-thatched building nestling in the shade. Perhaps you can see more than one, and there, stretching out from the beach is a wooden pier with, at its far end, fingers of decking spanning out over the clear blue water. And on those decks stand what many regard as the ultimate in beach hut holiday accommodation; thatched palaces equipped with state-of-the-art sound systems, air conditioning and their own jacuzzi spas. You can, of course, sleep in these luxury huts in the ultimate comfort, yet they serve much the same purpose as the rustic, brightly-painted shacks on beaches thousands of miles away. They allow people to enjoy the rejuvenating fresh air of the seaside and the special, uplifting quality of light, brightened by its reflection on the water, that makes time spent on the beach such a tonic.

People who love the beach hut way of life find it difficult to leave behind, but when they can't actually be there, sitting in the sunshine outside their hut, these beach hut devotees often enjoy little reminders to help them look forward to their next visit. At home they often decorate their mantelpiece with ceramic beach hut ornaments or book-ends, hang beach hut paintings on their walls, have china beach hut salt-and-pepper shakers on the dinner table or even wear a charm bracelet made up of tiny beach huts! These are the little signs identifying a devoted hutter, and they have become treasured keepsakes for those who aren't lucky enough to own the real thing. The beach hut has become an icon of popular culture around the world – a symbol of spirit and character which hutters, regardless of the costs involved in some areas, will maintain for generations to come.

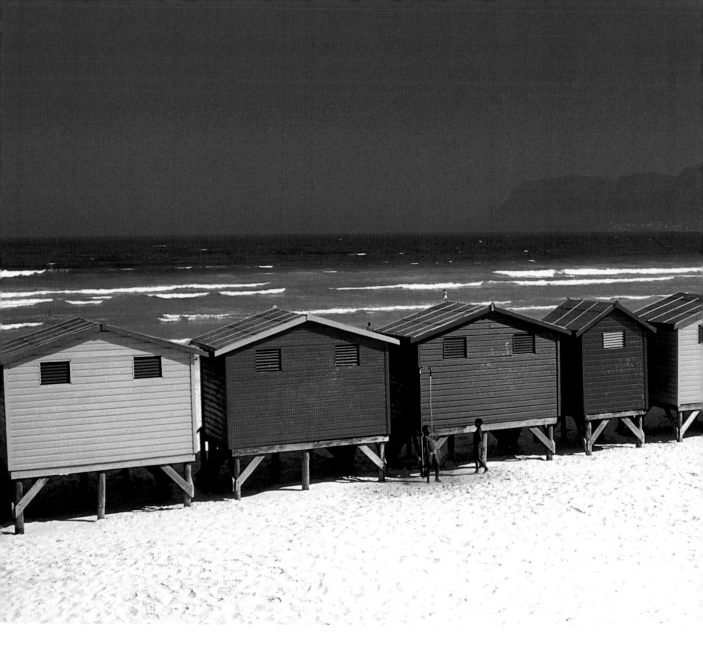

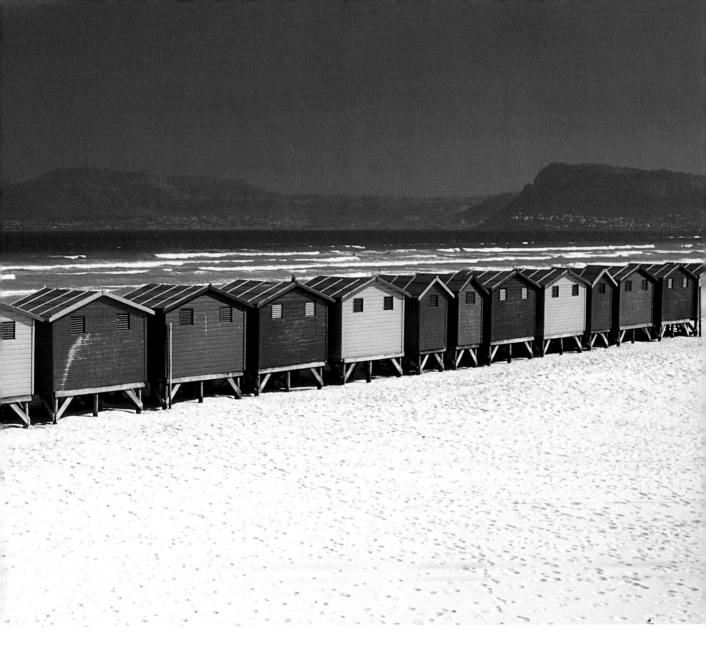

These South African huts stand well clear of the sand, giving a good circulation of air underneath to keep the floor dry.

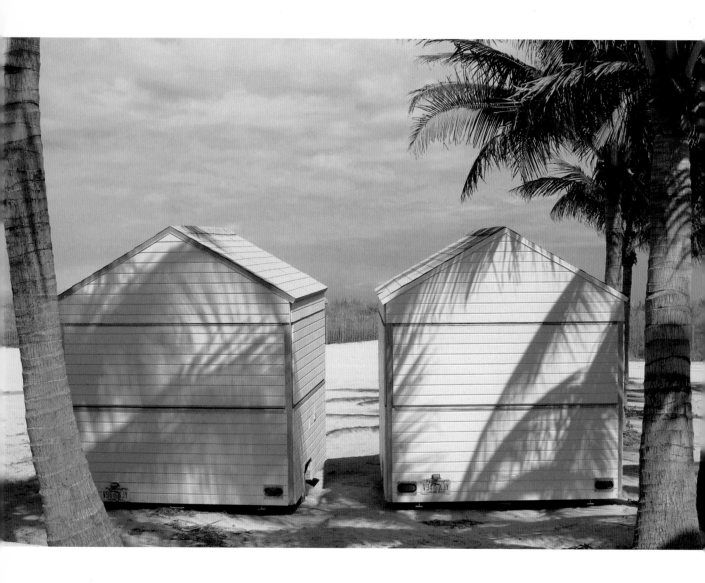

Above: These twin beach huts are in Miami, Florida.

Opposite: Shower on the beach at sunrise in these fun and practical shower huts in Corfu.

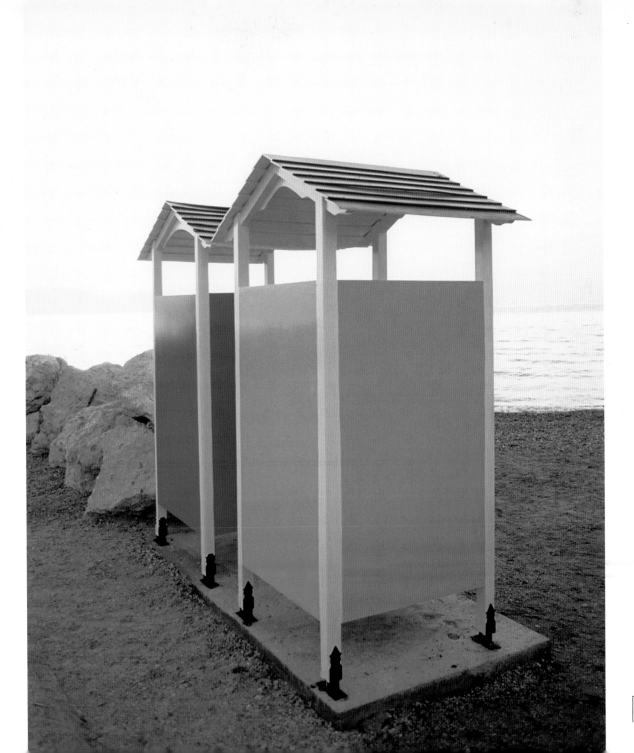

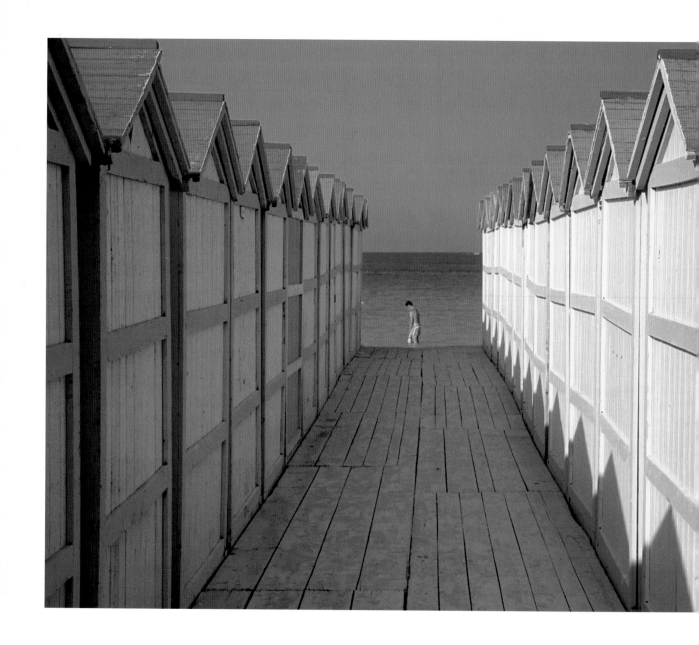

The well-tended terraces of huts in the
elegant resort of Mondello in Sicily.

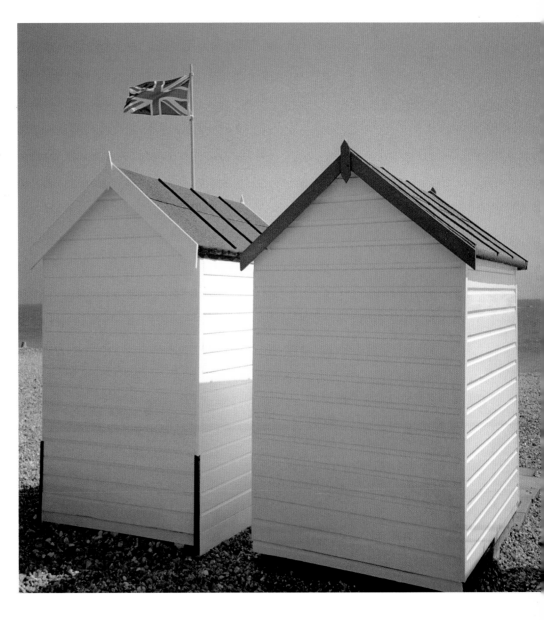

Flying the flag above the traditional style of
British hut on the south coast of England.

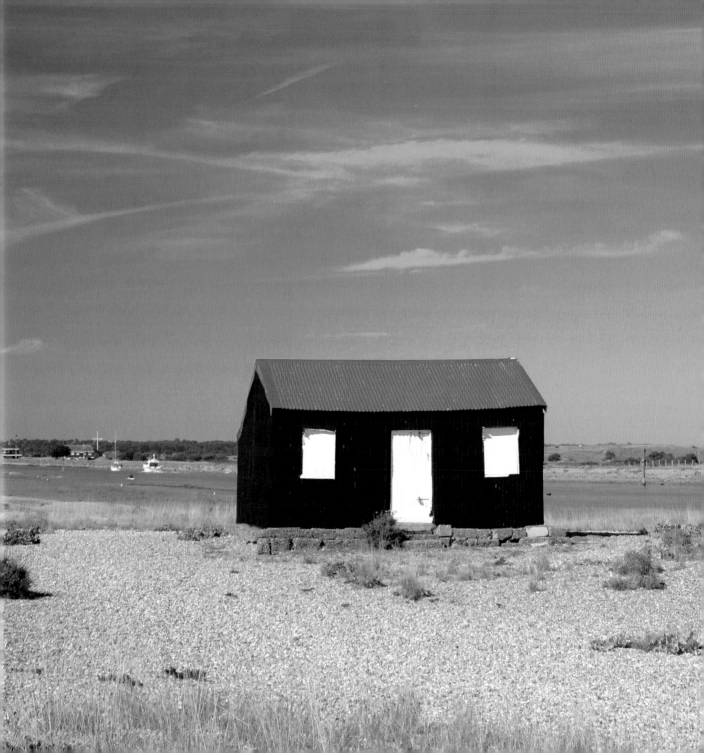

There is no escaping the sea on our little world. Around 75 per cent of the earth's surface is covered by water, the oceans forming a distinct and for many years impassable barrier between the slowly shifting continents, the constantly evolving nations and the vastly varied cultures that populate the planet. Both separated and connected by immense oceans, it is not surprising that the peoples of the world share a fascination for the sea. Some regard this as almost a physical connection: when we are born, we are made up of around the same percentage of water as the surface of the planet, so we have a natural affinity with the sea. Some say the rhythm of the waves rushing to the shore has a special calming effect on us, evoking foetal memories of life in the womb, when the rhythm of our mothers' heartbeats sending blood surging all around us was the sensation that dominated our every moment. Some would go even farther, claiming that we are drawn to the sea by a memory from beyond the womb, a primal memory of the time when all life on earth emerged from the oceans.

So what has all this got to do with beach huts? After all, the scaly things that crawled out of the oceans 400 million years ago did not fling open the doors of a shed, boil a kettle full of water to make a cup of tea, roll their stockings down to their ankles and slump in to a deckchair to read a newspaper in the sunshine. Their priorities were to find food, to find drink and to find a partner with which to procreate. The point is, though, that, however we try to analyze the lure of the sea, however many different theories we propose to explain its strange attraction, we will always come back to the fact that people 'do like to be beside the seaside'. Unfortunately, not all beaches are the most sensible places for people to live permanently, but beach huts provide a refuge and a practical

Huts come in all shapes, sizes and colours as with this English example in Rye, East Sussex.

SHACKS AND SHANTIES

facility for those who are determined to spend quality time by the sea. Beach huts exist as an escape for those who need to leave behind the clamour of modern city living, whether the hut is a white-washed clapboard shed somewhere on the coast or a thatch of reeds and palm leaves on a tropical island in the Pacific. Beach huts today are for leisure and pleasure, places for stressed people to relax and unwind; but that has not always been the case.

In the past, beaches and the sheds, shacks, huts and shanties thereon were working environments, places where fishermen launched their boats and tended their nets or where adventurers set off across the sea to trade; not the places for pleasure seekers we now know and increasingly love. The great seafaring nations of the ancient world around the Mediterranean relied on their sandy beaches and sheltered coves to establish the ports that sustained the development of their civilizations. It was not, however, advisable even for these people, who owed their very existence to the sea, to live on the beach. Beaches are, by their very nature, exposed places and can be cruel, unforgiving environments. Although there is less tidal activity in the Mediterranean than in other parts of the world, building a dwelling directly on the beach might have meant sharing your home from time to time with the incoming tide. It would also leave your home exposed to the wind coming in off the sea and vulnerable to being battered by the elements during stormy weather. As a result, people tended to establish major settlements away from the beach, where they could find shelter in coastal forests or behind rolling banks of sand dunes. More importantly, they could also find fresh water farther inland, the great essence of life that is seldom available in close proximity to a beach. However, if you work at the beach or at the water's edge, it makes sense that you

build some sort of temporary structure there to store your tools, shelter you from the wind when you are working and provide protection by shading you from the scorching rays of the sun. Rough shacks and huts, therefore, became an established feature of coastlines around the world long before the advent of the pleasure beach. Using beaches for rest, relaxation, health and recuperation was a phenomenon that developed long after most of the populations of the more developed countries had turned their backs on the sea. People had to be lured back to the beaches.

The sea has always been a dangerous place. The mighty supertankers and container ships traversing the globe today still come to grief from time to time, despite their size and strength and despite the technological wonders of radar, sonar and satellite navigation. Venturing out on the ocean in past centuries in flimsy wooden ships was a perilous undertaking and those who did so needed to match their skills in navigation and seamanship with equal amounts of daring and fortitude. These courageous mariners set sail not only to fish or to trade but also to conquer and plunder. This made living near a beach where ships could land even more hazardous. Waving goodbye to some of your own brave warriors as they departed for far off shores was one thing, but seeing the masts of foreign marauders appear over the horizon was quite another. Whether the foreigners were Viking raiders in northern Europe or Carthaginian pirates in the Mediterranean, their arrival on the shore was bad news for the locals. It became common around the Mediterranean in places like the Spanish island of Mallorca for a port or trading centre to move inland, becoming two towns. Thus there is Port de Soller or Port de Pollenca on the Mallorcan coast and the towns of Soller and Pollenca a few kilometres inland. This gave the inhabitants of the towns some protection from

Breakwaters protect the shingle coastline of Eastbourne,
Sussex, where these pristine huts nestle.

The sloping, white-painted roofs of these English huts in Eastbourne
stand proud like an alpine mountain range.

coastal raiders, the port being only their first line of defence. By the time the invaders had captured the port, the inhabitants of the distant town would have prepared solid defences should the attackers rampage farther inland.

There were countless other reasons for populations to move away from the coast. Sustaining an existence from the sea was a hard and dangerous life and it is easy to understand how farming, hunting or fishing inland would have been seen as a safer option. Slowly, the development of transport links, mining and industry in the Industrial Age meant that the coast was somewhere you need only go if you had something to export, or you were planning to travel. Ordinary people who worked in fields or factories inland in Europe or mainland Britain might never have any reason to venture outside the boundaries of their own villages, let alone visit the coast. However, those same ordinary people would become the ones who established and maintained what we all now know as the 'traditional' beach hut. Before they could do so, of course, they had to be extracted from their squalid city dwellings and given not only the opportunity but also the means to travel. The opportunity came when statutory holidays turned industry's mass labour force into mass tourists. However, these were not the first holiday-makers, and the birth of the beach hut owes less to the working classes than it does to high society hedonists.

# The first tourists were a very priveleged minority of the
population. Up to around the end of the 16th century, there were no such things as
holidays for ordinary people. A holiday really was just what it said: a 'holy day' when
work had to be set aside. A holy day meant Sunday, which would be spent in church or
in religious observance, reading the Bible, or it meant Christian festivals such as
Christmas, although not every worker was granted a whole day off, even for Christmas.
Only those who were rich enough not to have to work for a living had any real leisure
time. The aristocracy and those who aspired to the upper classes looked down upon
those who had to work for a living, and they spent their time in the pursuit of sport –
horse racing, gambling, hunting and shooting. They devoted a great deal of time to
social pursuits, maintaining their status in society by associating with the right sort of
people. In order to mix in the right circles, one needed to have had a proper education:
an understanding of the sciences, a basic knowledge of Latin and Greek and an
appreciation of art, architecture, music and literature. Since the first museums in
Europe did not appear until the end of the 18th century, for a young man (a lady's
education was seen as being of far less importance) to learn about great classical
paintings and sculptures, he really had to go and see them for himself. This
educational pilgrimage would be accomplished by sea, on horseback or in a horse-
drawn carriage – even the most rudimentary rail travel was still two-and-a-half
centuries away – and became known as the Grand Tour. The tour took in Paris, Venice,
Florence and Rome, and the young men from Britain and northern Europe would often
be accompanied by a guardian or tutor on their travels, journeys that would take many
months to complete. Letters would be sent in advance to request permission to visit

the grand houses of art lovers to view their collections, with letters of introduction or accreditation also carried by the tourists.

These rich young men generally travelled in style, taking with them as many comforts as could be packed in their carriages. Now highly prized as antiques, items such as the Grand Tour table, which folded away for easy storage, were taken with the intrepid traveller, (the problem of space that afflicts beach hut owners is not a modern phenomenon). Another legacy of the Grand Tour is the GT or 'Grand Tourer' badge seen on modern cars. Souvenirs in the form of paintings or sculptures were collected and sent home along the way and, when the young man himself eventually came home, provided he had managed to avoid all of those troublesome European wars, he would have had the

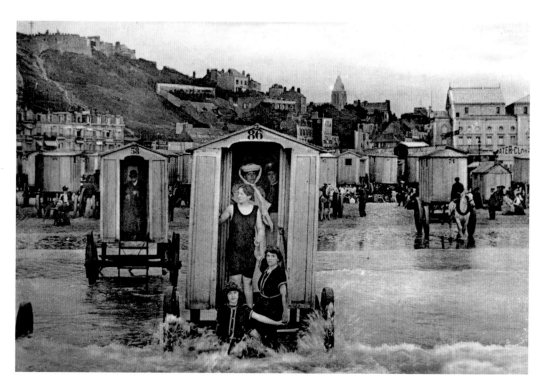

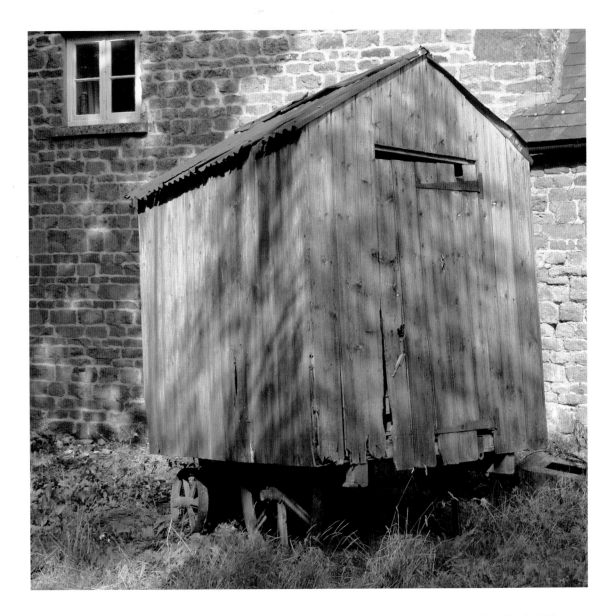

Above: A sadly neglected relic from a bygone age, this bathing machine is beached for the last time.

Opposite: Bathing machines were drawn into the water by horses whereupon the occupants could walk down the steps into the sea. This photograph is from Boulogne, in northern France, circa 1905.

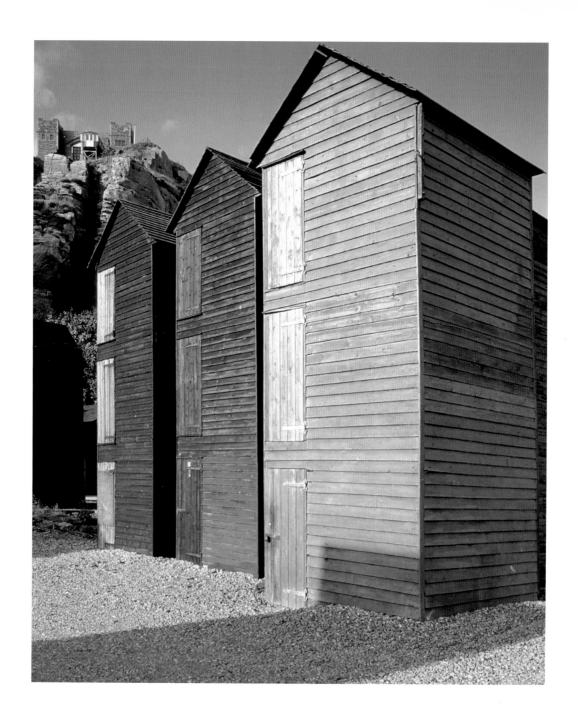

holiday of a lifetime. The Grand Tour was an initiation to be undergone by one generation after another (with varying degrees of success) right up to the early years of the 20th century. It may have been the first kind of organized holiday, but those embarking on the Grand Tour adventure generally had the time and the funds to afford the most luxurious accommodation available when they were on the road – not for them the humble beach hut – such rudimentary accommodation would not have featured on the Grand Tour itinerary, though their exploits led indirectly to its development.

The Grand Tourists established the notion among the upper classes in Britain that travel broadens the mind, giving one not only a healthy outlook but also a robust constitution. By the early 17th century, a change of scenery and some bracing sea air were regarded as being just the thing to invigorate and rejuvenate even the most jaded of socialites. Spa towns, such as Bath and Tunbridge Wells, where the Romans had built baths to enjoy the beneficial qualities of natural mineral water springs, had a new lease of life under the patronage of the aristocracy when it became highly fashionable to bathe in and imbibe spa waters as a cure for ailments both real and imaginary, from goitre and gout to lumbago and nymphomania. In 1620, Mrs Elizabeth Farrow discovered spa waters flowing into the sea at the North Yorkshire harbour town of Scarborough, leading to the town being promoted as a rival to the other Yorkshire spa town of Harrogate. Scarborough can, perhaps, lay claim to being the first truly commercial seaside spa town, but Brighton has some justification for calling itself the birthplace of the British seaside resort. In terms of class, the early development of all British seaside resorts relied on the gentry, who had both leisure time and disposable income, rather than on those less affluent beach lovers who would create the cult of the hut.

**The sky scraper of beach huts. The fishermen of Hastings use these huts for drying their nets, a reminder of the practical origins of beach huts.**

As the rich began to pursue pleasure and relaxation in earnest, the seaside village of Brightelmstone, as Brighton was then known, which had previously been home only to fishermen, traders and smugglers, was fast becoming the most fashionable leisure retreat in the country. This had a great deal to do with the patronage of the Prince of Wales, later Prince Regent and ultimately King George IV, who rented a farmhouse near the town. The farmhouse was extended for him in 1787 to become the original Brighton Pavilion, the magnificent Royal Pavilion that now exists being a further extension and redesign undertaken between 1815 and 1822 to provide a grand, Indian-style royal seaside palace. When, as Prince of Wales, young George first visited Brightelmstone in 1783, it was to experience the charms of sea bathing as well as the charms of a certain Mrs Fitzherbert whom he secretly married. The prince's father, George III, also enjoyed sea bathing, choosing Weymouth for his first experience of salt water immersion in 1789.

The new craze for sea bathing was largely created as a commercial enterprise by the medical profession, who saw the fortunes that were being made in the inland spa towns with their mineral water springs and decided that the rich could just as easily be persuaded to part with their money in coastal resorts with the far more plentiful salt sea water. In 1667 Dr Robert Wittie in Scarborough was recommending to those who consulted him that sea water was just as good as mineral water for curing gout, arthritis or any other ailment. The correct period of immersion and the amount of sea water to be consumed for different medical problems was where his advice and supervision became invaluable. Towards the end of the 17th century and the beginning of the 18th, respected physician Sir John Floyer was well known for advocating hot and cold water treatments,

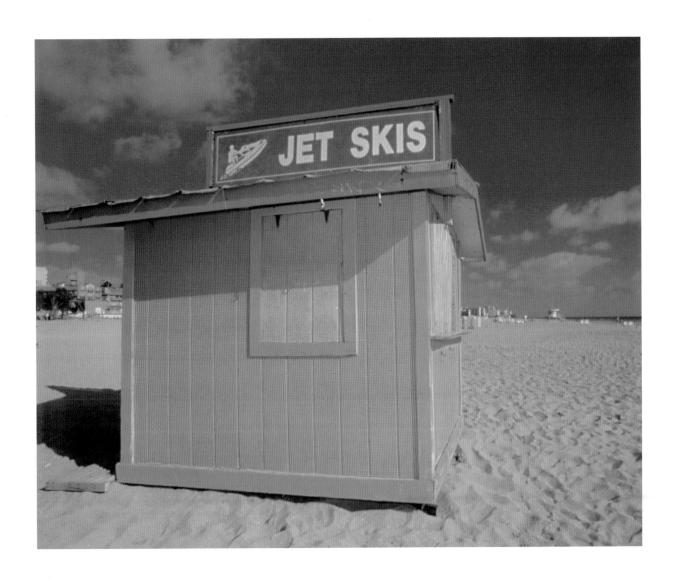

On many beaches, as with this one in Florida, the only huts you will find are those that function as bars or water sports' rental facilities.

aquatherapy or hydrotherapy for various medical conditions, pointing out that the Greeks and Romans had understood the benefits of such cures many centuries before. In 1750, Dr Richard Russell, from Lewes in Sussex, published his 'Dissertation on the Use of Sea-Water in the Diseases of the Glands, particularly, the Scurvy, Jaundice, King's-Evil, Leprosy and Glandular Consumption' and built Russell House in which to care for his patients in nearby Brighton, recommending that the sea water around this precise stretch of coastline was particularly beneficial.

Sea bathing for medicinal purposes was nothing like the dip in the sea we can all enjoy today. There were a great many rules that had to be followed to maintain the dignity of polite society. Men and women bathed on different parts of the beaches, there being laws that strictly forbade mixed bathing. In the 17th and 18th centuries, men would generally bathe naked, jumping from boats some way from the shore. Ladies would wear long flannel shifts with long sleeves and douse themselves in the breaking waves near the beach. The more outrageous members of both sexes would seek out vantage points on the cliffs where they could spy on one another using telescopes. To protect the modesty of the ladies, therefore, the bathing machine was developed. The first manifestation of the bathing machine probably appeared in Scarborough around 1735 and was simply a shed mounted on a cart that was pulled into the sea by a horse. This allowed its occupant to enter the shed fully clothed on dry land, change into his or her bathing costume (although a gentleman might not wear one) for a quick dip in the sea and then re-emerge from the shed, again fully clothed, once it had been pulled back up the beach. With the entire contraption dumped in the sea, with him (or her) inside, the bather could this way minimize the risk of exposure to onlookers.

The custom-built bathing machine, devised by Benjamin Beale, first appeared in Margate around 1750 and was a far more elaborate affair than the Scarborough shed-on-a-cart. When Beale's horse-drawn machine was eased into the water, a hooped canvas awning could be lowered around the exit, providing a 'tent' that reached down to the surface of the sea and complete privacy for the bather. In this way, both gentlemen and ladies could bathe, as some guide books put it at the time, 'the one without violation of public decency, and the other safe from the gaze of idle or vulgar curiosity'. The idea of the bathing machine quickly took off and soon all of the newly developed resorts around Britain's coast, from Blackpool and Bognor to Teignmouth and Torquay, had fleets of bathing machines lining the shore. George III's dip in Weymouth in 1789 was from a bathing machine, and in September 1805 when Nelson boarded HMS *Victory* to leave Portsmouth for the last time, the boat that took him out to his flagship departed from the fast-developing resort at Southsea near its new bathing machines. As he put it in his diary: 'At six o'clock arrived at Portsmouth and having arranged all my business, embarked at the Bathing Machines....' These machines were truly the forefathers of the beach hut however, while so many people have derived so much pleasure over the years from owning or renting beach huts, the bathing machine was for many less of a place for relaxing leisure time than it was a veritable torture chamber.

For ladies, especially, following medical advice and spending five or six weeks at a seaside resort meant enduring the trauma of the bathing machine experience each morning. Individual bathing machines, or sometimes whole fleets, were run as family businesses. The husband would tend to the horse and the wife, invariably a robust woman, would be the 'dipper' whose job was to attend to the lady talking to the water.

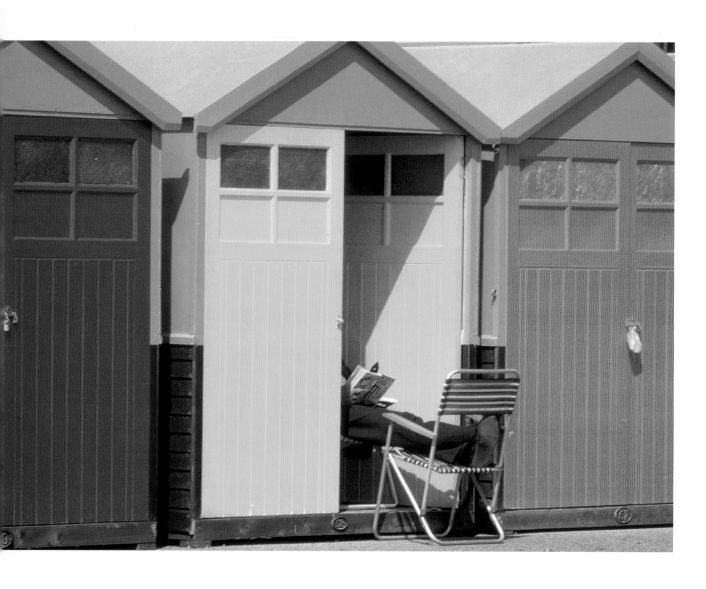

A traditional pastime, undertaken outside a traditional hut in Brighton, England.

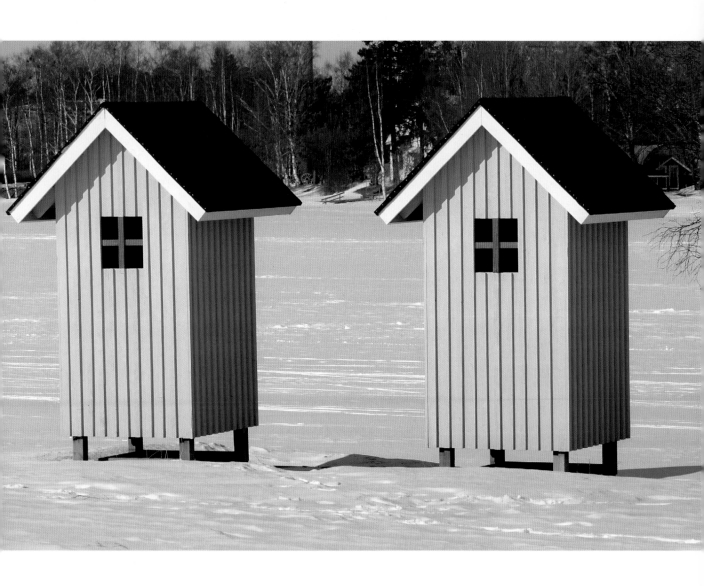

Not quite such a traditional setting, but still a shelter

from the elements in Oulu, northern Finland.

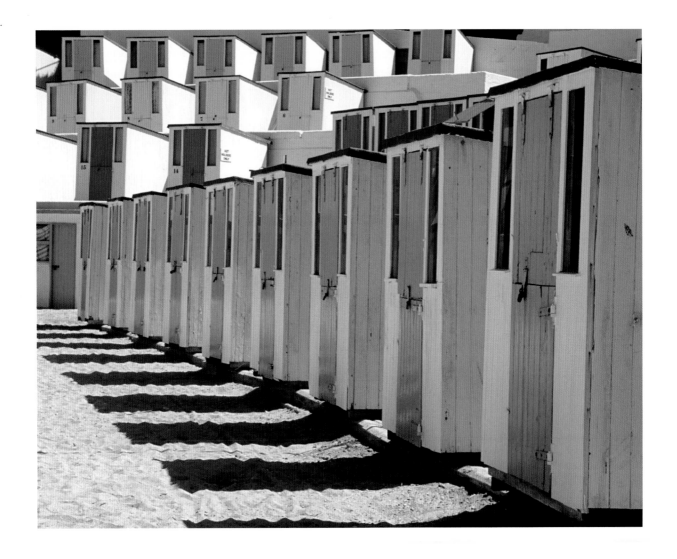

Above: In many beach hut communities, like this one in Newquay, Cornwall,
there are restrictions on the colours the huts can be painted.

Opposite: Stripes, reflecting the colours of sails and deck chairs, make for ideal beach hut
colour schemes, as demonstrated by this hut on Prince Edward Island in Canada.

Having paid a not insubstantial fee, the lady would climb the steps into the bathing machine and change out of her day clothes into a long smock that was weighted with lead at the ankles to stop it from riding up in the water. Once the machine was in position, the door would be opened and she would walk down the steps into the water under cover of the awning. Few people, including most sailors, could swim in those days, and this was really not the purpose of sea bathing. It was immersion in the icy cold water that was being promoted for sound health, and this was where the dipper's job began in earnest. Grasping her charge firmly around the waist, the dipper would wait for a good-sized wave and then plunge the young woman under the water, holding her there no matter how hard she struggled. The dunking would be repeated several times before the bather, exhausted and half drowned, was returned to the safety of the machine to be vigorously towelled dry. She would then dress in her normal warm clothes as the machine was towed back up the beach, where she would disembark and return to her lodgings or hotel for a hot drink and a well-earned rest.

Some dippers became firm favourites in the resorts, trusted and revisited time and time again by regular clients. In Bognor, Mary Wheatland worked as a dipper from the age of 14 and went on to own her own bathing machines, becoming known as 'Bognor's Mermaid' and still working in the resort, albeit as a proprietor of the machines and not a dipper, when she was in her 70s. Martha Gunn, dubbed 'The Venerable Priestess of the Bath', became something of a celebrity in Brighton, working at the beach for 70 years up to her death in 1815.

The bathing machines were in constant use in the resorts in the mornings, doctors recommending that the 'dip' be taken when the water was chillingly cold, but the

resort beaches were not, in the early days, places where decent people could relax. In Brighton, Dr Russell's establishment was built on what had been common land where fishermen persisted in laying out their nets to dry and the Prince of Wales would have seen herds of pigs foraging on the foreshore when he first visited in 1783. It soon became clear, however, that there was money to be made in providing entertainment for the holiday-makers, so promenades were built where a stroll in the fresh air after lunch afforded holiday-makers the opportunity to pass the time of day. For those under strict doctor's orders, there would be a treatment diary to complete, recording every detail of their symptoms before the afternoon visit to their physician, but for those attending the resort for its social society, a 'Master of Ceremonies' coordinated a range of activities that, once the gentlemen had enjoyed boating, riding or playing cricket and the ladies had visited local markets, sketched ruined abbeys or studied the local flora and fauna, involved musical interludes, grand dinners or elaborate balls in the most elegant hotels or assembly rooms similar to those of the inland spa towns. Time was also set aside for reading, and no resort was complete without its own lending library.

# The new breed of holiday-maker

was an entirely different kettle-of-fish. So much for the life of the upper classes at the seaside, but when did the hoi polloi start to arrive? They, after all, are essential to the story of the beach hut. The first working-class people to visit the seaside, apart from those who were already living and working in the area, were the servants of the rich holiday-makers. It could be an expensive business, of course, travelling with servants, and tedious, too, as the journey from London to Brighton by stagecoach or private carriage in the mid-18th century would take an entire day. Towards the beginning of the 19th century, better road links had reduced this to just nine hours, but holiday-makers heading for the Kent resort of Margate found it cheaper to send their servants on the freight barges that brought grain from Kent to London. The barges' return journey was generally made without cargo, and the barge owners quickly realized that providing cheap passage on their boats could boost profits. The holiday-makers' servants undoubtedly spread the word among their friends about the marvellous time people had at the seaside, and being able to travel on the grain barges encouraged those living and working in the docks of London's East End to plan their own seaside jaunts. This became even cheaper and faster with the introduction of steam ships in the early 19th century, but with more people than ever arriving in the resorts on ships that were bigger than ever before, getting them ashore became a problem. Transferring passengers to rowing boats and then carrying them through the shallower water was not ideal, so the resorts developed landing stages or piers. The earliest piers were built at Margate, Deal, Herne Bay, Southend, Brighton and Great Yarmouth, with these

**Larger huts with tiled roofs stand below the funicular at Bournemouth in England.**

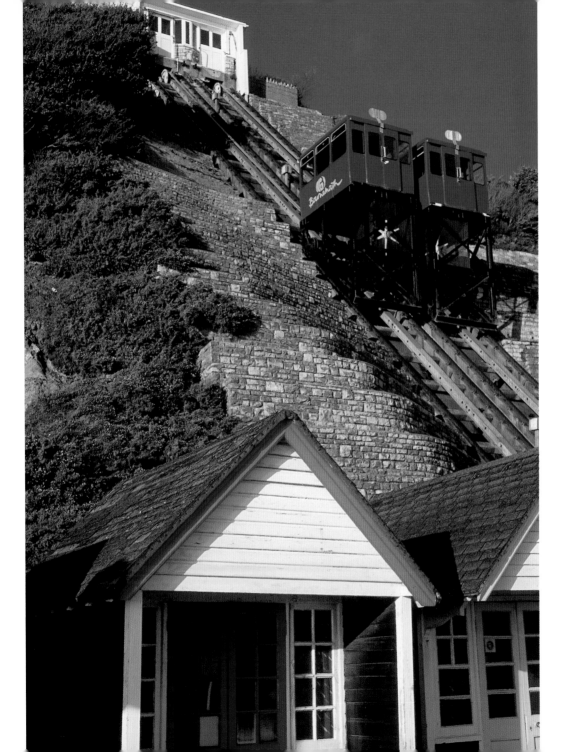

structures acting not only as landing stages, but also as extensions of the promenades and a leisure facility in their own right. They also provided yet another vantage point from where anyone with a telescope could spy on members of the opposite sex using the ubiquitous bathing machine.

By now, however, the purpose of the bathing machine was changing. By the middle of the 19th century, it was fashionable not just to be dipped in the sea but also to learn to swim, so bathing machine proprietors like the Capps family at Gorleston near Great Yarmouth began to give swimming lessons. The bathing machines were still towed out into the water, but the physical contact with the dippers, which rich gentlefolk found so distressing, was becoming a thing of the past. Instead, instructors like the Capps used long wooden poles from which were suspended ropes that were tied under the pupils' arms. In this way they could support their pupils in the water, like an angler with a huge fish on his line, while calling out instructions. Ridiculous as it may seem to us now, the social conventions of the time made such elaborate measures a necessity, especially if the female swimmers under instruction were not to sink under the waterlogged weight of their voluminous bathing outfits. Less restrictive bathing costumes from Europe gradually became the norm as the fashion for swimming took hold. Gentlemen were required to wear swimming drawers – long shorts with a drawstring at the waist – or, as these had a habit of falling off when waterlogged, a one-piece costume that resembled a T-shirt and shorts. Ladies still wore a sack-like dress, but it was shorter and worn with bloomers, at least giving them the chance to attempt to swim. Following the practice that had existed in European resorts for many years, beaches were no longer segregated and families could swim and sit on the beach together.

Much larger family bathing machines were soon introduced and, for the less affluent bathers who flocked to the seaside as the new railway network opened up resorts like Blackpool to mass tourism, the bathing machine operators provided the opportunity to hire bathing suits and towels. Few working-class people would go to the expense of buying their own costumes because they had few opportunities to use them – the Bank Holiday act of 1871 allowed some workers just four days off each year, one of these being 26 December, not the ideal time to go swimming in the sea. Proper holidays for working people, rather than just a handful of isolated days off, became a reality when the northern mill towns introduced Wakes Weeks. The Wakes Week had traditionally been a time when travelling fairs visited towns and villages, but mill owners, pressurized by government employment legislation and a growing militancy among their own workforces, began closing down their factories for a week at a time. This helped to stop unauthorized absenteeism, and giving their workers a week's summer holiday, albeit initially unpaid, not only improved industrial relations but also gave the mill owners a chance to effect essential maintenance when their machinery was shut down.

Different mill towns opted for different weeks for this annual holiday, and the workers would save a little from their wages each week to pay for their seaside holiday in Morecambe, Blackpool, Filey or Whitley Bay. The rail companies laid on special trains to cope with the mass exodus of the workforce, taking them from the dark and dingy mill towns to the bright clear air of the seaside. Escaping from the oppressive atmosphere and lifestyle in the towns made people feel healthier, fitter and rejuvenated. The smoke from the chimneys of the mills and from their own home fires made the towns where the factory workers lived decidedly unhealthy places. For much of the year, people, including

children, would leave home early in the morning to go to the factory and return late in the day, never having seen the sun shine. Coupled with a poor diet, this led to the spread of diseases like rickets. Rickets is a vitamin deficiency that prevents the proper growth of bones, leading to 'knock knees' or 'bow legs', which were common deformities in industrial towns at the beginning of the 20th century. It is just one condition that can be prevented, in part, by exposure to sunshine. Breathing the fresh sea air and spending days outdoors on the beach was, therefore, a real tonic for this new breed of holiday-maker, even without them having to resort to the dubious 'cures' that had been undertaken by their privileged predecessors.

In 1901, the laws covering segregation were finally abandoned completely and families were free to spend their days together playing on the beach or swimming in the sea. Many resorts still found it desirable to maintain distinctly separate bathing areas, however, with the best beaches being reserved for their upper-class visitors while Wakes Week workers, whose drinking and frolicking in the sunshine was deemed likely to offend by upper classes and authorities, were confined to a decidedly separate area, which became less cared for and, as a result, was not as nice as the upper class niches.

Visiting the seaside for a week did have its drawbacks for the factory crowds. Most would stay in guesthouses where they were obliged to leave after breakfast and not return until late afternoon. This gave them all day to spend outdoors, walking, visiting local amenities or sitting on the beach. The vagaries of the British weather, of course, meant that not every day was going to be suitable for sitting on the sea shore. What they needed was a family base where they could shelter from the odd shower of rain without having to spend their hard-earned savings sitting in cafes or bars, and

when they were at the beach, they needed a place to change into their bathing suits.

The bathing machine operators were not slow to spot a new opportunity. As demand for their services by those under doctors' orders declined and the hardier working-class holiday-makers began taking to the water under their own steam, crashing through the breaking waves on the shore rather than paying to be carried out to calmer water, they turned their attention to the needs of these new beach users. If a hut on wheels at the water's edge was no longer required, then perhaps there might be a demand for a stationary hut farther up the beach. Although bathing machines did not disappear completely from British beaches until the 1920s, in the early years of the 20th century the ranks of wheeled huts on the shoreline were slowly replaced by lines of wheel-less huts standing high and dry much farther up the beach beyond the high-water mark. For those who could afford the modest fee, beach huts could be hired either by the day or for a whole week, providing not only a changing room but also a place to store beach chairs, wind breaks, towels, toys, buckets, spades and all the paraphernalia of a trip to the beach. For many, the beach hut became not just a convenient store or shelter, but an integral part of their annual family holiday with so many cherished moments. So many fond memories centred around the simple wooden structure, that looking forward all year to the next holiday, saving a few pennies each week, meant not only revisiting the seaside, but revisiting the beloved beach hut. Over the past century, British seaside resorts have changed enormously, dress codes and bathing suits are vastly different, more people arrive in the resorts by car than they do by train or by boat, the dippers have gone, the bathing machines have gone, but the beach huts have endured, more popular, more numerous and more highly sought after than ever before.

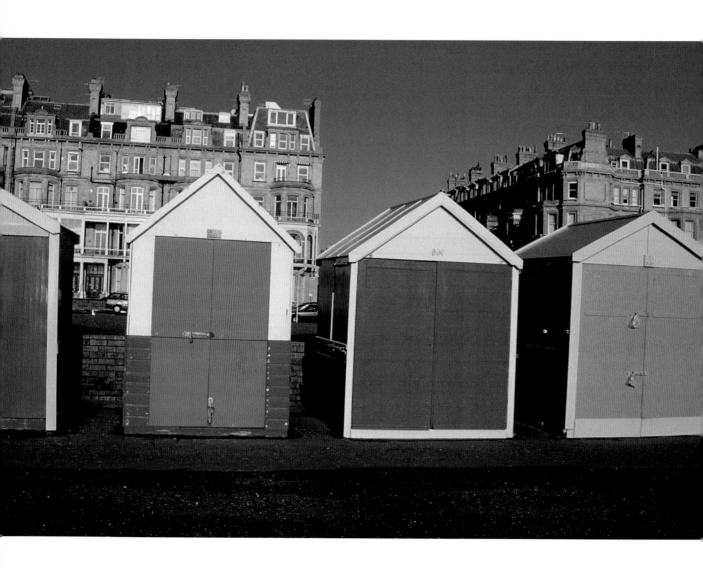

Elegant terraces of Victorian buildings form the backdrop for
this image of huts on the seafront at Hove in England.

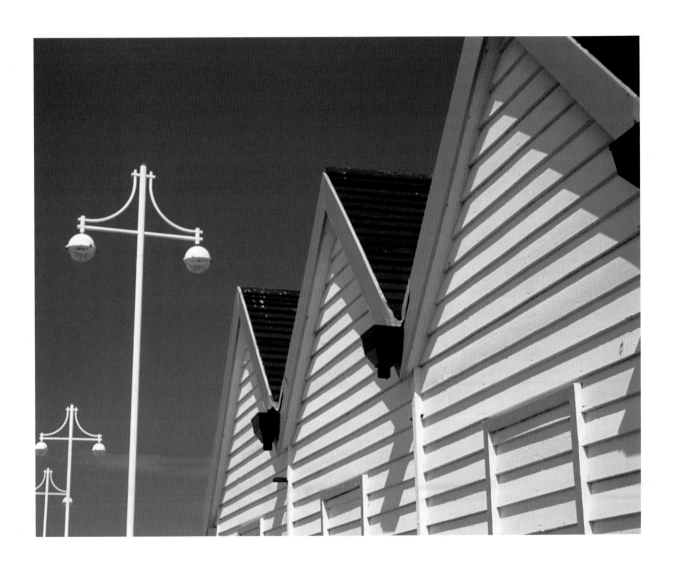

The blue trim of the fascia boards forms attractive peaks
against the blue sky in Brighton, England.

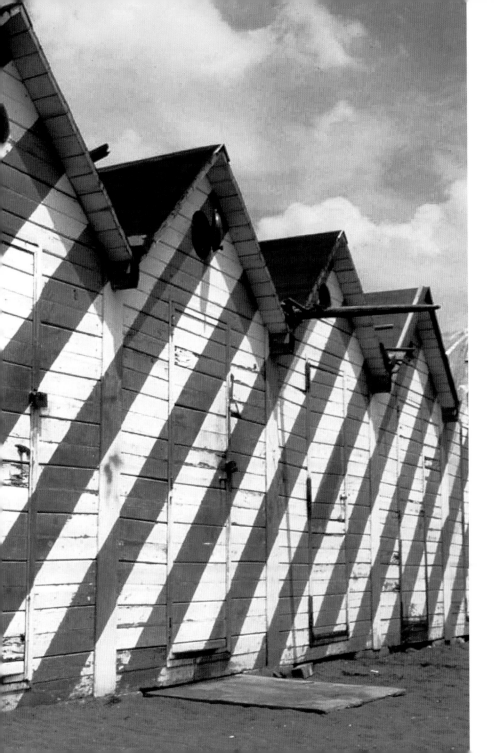

These Italian huts have
the stylish colour scheme
to match their fashionable
home, Naples.

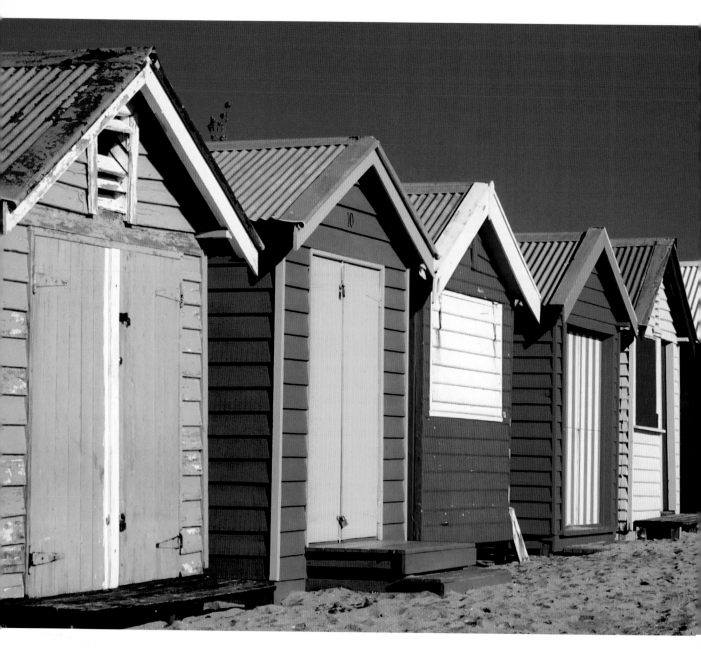

The free-form colour schemes create a jolly display in this row of Australian huts.

# By the end of World War 1 the beach hut was

firmly established as part of the beach landscape at seaside resorts throughout Britain, although their use and proliferation began to be regulated just as the resorts themselves were being more carefully managed. The growth of the seaside leisure industry led to different towns developing different characters. Places like Southend, Ramsgate and Margate were destinations dedicated to mass-market tourism, with day trippers arriving by train in their thousands. For many years, however, towns like Brighton, Bournemouth and Eastbourne strenuously resisted what they saw as a drive downmarket. Eastbourne, in fact, was largely owned by the Duke of Devonshire, who regarded the fairgrounds, circuses, zoos, music halls and drinking dens of other resorts as distinctly undesirable and for years blocked any commercial development at the waterfront. In May 1899, the Town Hall in Eastbourne presented a show by the Moore and Burgess Minstrels that was advertised as 'Fun Without Vulgarity'. The upper classes were looking for a far more genteel and sedate seaside break than those who were leaving behind factory life. In most areas, the class system ensured that neighbouring resorts adopted different standards. The small seaside town of Brid came to be regarded as superior to Filey, for example, while Cliftonville was a cut above Margate. This pattern of social discrimination was repeated across much of the country.

Beach huts, however, made their presence felt wherever there was a suitable beach. Whatever your social standing, there were still certain rules of decorum that had to be followed. Right up to the 1950s, it was not generally acceptable to dress or undress in full view of other beach users, and it was common practice for people to wear their best suits or dresses for a visit to the beach. It was not unusual to see gentlemen of all

## A FOOTHOLD IN THE SAND

social classes sitting in deck chairs fully clothed in suits, shirts, hats and even ties. The fashion for sunbathing did not really catch on until the 1960s, the prevalent attitude (a throwback to Victorian times) being that sun-tanned skin was seen on only the most lowly manual workers who laboured in fields or on building sites outdoors all day. Pale skin meant that you were of a higher social standing than such manual labourers. Understanding why too much sun can be harmful to your skin is a relatively modern phenomenon, although overexposure to the sun was previously thought to cause all manner of ailments – not all of them imaginary. However, for the young and adventurous, at least part of the day could be spent swimming, romping around or building sandcastles on the beach. For that, you really had to be dressed in a bathing costume. Getting into your costume, however, was a tricky operation. Those who chose to do this, had to wrestle with their clothes and battle with their swimsuits while trying to maintain their dignity by keeping themselves completely covered with a beach towel that, aided by even the slightest of breezes, was determined to fly into the air and expose everything you were so desperately trying to keep under wraps. What you really needed was somewhere to change. This meant that the beach hut's place as a family base and changing facility was assured.

In the summer of 1919, with the war in Europe well and truly over, the resulting optimism and relief sent people flocking to the seaside to unwind in the sunshine, and it became highly desirable to have your own beach hut. While beach lovers were prone to building their own shacks in more secluded spots, using driftwood and whatever else could be found lying around, the traditional beach hut 'shed' on the more popular resort beaches was what every regular beach-goer really wanted. The local authorities who

managed the beaches in England, however, simply could not allow huts to spring up at will. Maintaining the seafront as an attractive amenity for holiday-makers and, therefore, a source of revenue for local people through the tourist trade became a major priority and the spread of beach huts had to be kept in check. Beaches were beauty spots that had to be preserved, or at least developed in a sensible way, not turned into seaside shanty towns. Beach huts, therefore, became the subject of increasing legislation to ensure that they remained in keeping with the nature of the resort and did not evolve into eyesores. Most beaches, of course, were public places, administered by the local authorities, and gradually most beach huts came under the control of local councils rather than the private individuals who had operated them in a similar fashion to bathing machines. It was, and still is, possible to hire a beach hut for the day or for a week or to rent one for the entire summer season. Though you may be able to buy a beach hut, the promenade or patch of sand on which the beach hut stands will usually remain under the control of the local council. This means that, in times of crisis, the local authorities can limit or ban access to the shoreline, such as happened during World War II when Britain fell under threat of invasion and the beaches were fully expected to become battlegrounds. The barbed wire, concrete gun emplacements and tank traps that sprang up on Britain's beaches during the war, along with widespread travel restrictions and the absence of holiday-makers due to military service, put paid to the great seaside holiday for a while, but by 1948 when the Holidays With Pay Act came into being, more people than ever before headed for a seaside summer holiday. If you could afford to hire a beach hut, it was once again very much the thing to do and the brightly painted wooden huts blossomed as never before.

In some places, the huts were not quite what they seemed. What looked like a beach hut might, in fact, have been actually a railway carriage. The idea of 'camping coaches' was first tried out by the London and North Eastern Railway in the 1930s, when they fitted disused passenger carriages with beds, kitchens and living areas, parking them in quiet country station sidings to act as caravans on rails for cheap family holidays. Camping coaches were fairly widespread by the 1950s but, in St Helens on the Isle of Wight, they took the idea one step further. There, some of the island's surplus rolling stock was transformed by being given a clapboard overcoat and roof to make the carriages look just like a terrace of beach huts painted in jolly seaside colours. From a distance, the only external clue that might make you think all was not as it seemed was that the huts all still used the existing train carriage slam doors.

As the nature of the British annual holiday changed, so too did the status of the beach hut. With the coming of the jet age in the 1960s, cheap package holidays to Spain tempted Brits away from their traditional home resorts for the guaranteed sunshine of the Mediterranean. British holiday resorts, especially those in the north where the summer weather was far from reliable, went into decline. Beach huts in some areas were abandoned and fell into disrepair, eventually being battered to pieces by the merciless wind and rain over countless winters of neglect. Neglect had also been part of the problem faced by British resorts. Poor standards of accommodation and beaches so polluted with thousands of tons of raw sewage, pumped straight into the sea during each summer season, made it practically impossible for British seaside holiday destinations to compete with the delights of Spain, the Balearics, Italy or Greece. Indeed, some victims of the polio epidemics that crippled or killed thousands of children in the 1940s and

1950s blame swimming in polluted water for the spread of the disease. Great efforts have been made in recent years to improve British beaches and the general standard of the resorts, with local authority tourist organizations using, among many other tactics, one particularly strong lure to tempt holiday-makers back to their beaches: the beach hut.

All over the country, local councils have been introducing or reintroducing beach lovers to the joys of the beach hut. Not only have the councils helped to boost the popularity of the resorts by renting out beach huts, but they have also made the beach hut incredibly fashionable once again. At Goring-by-Sea in West Sussex, for example, Worthing Borough Council now has 111 beach huts for hire, along with 55 chalets, a larger version of the beach hut in which you might consider sleeping overnight. Such chalets cannot really be viewed as traditional beach huts, but they do serve to proliferate the cult of the hut. There are also 285 privately owned huts in the area, Worthing Borough Council charging owners a fee for the 'pitch' – the ground on which the hut stands – on an annual or seasonal basis. The council is one of the few that insists that all of the huts are painted white and over 250 of them line the sea wall. Walking down the beach when the tide is out on an overcast day, you can turn to see the row of whitewashed huts against a leaden sky looking for all the world like teeth and making you feel like you are looking out from the belly of some monstrous sea creature. In the sunshine, on the other hand, they are a dazzling string of pearls along the shoreline.

Dover District Council has 14 beach huts for hire in a private compound at St Margaret's Bay and another 23 pitches or plots where beach lovers can erect their own huts at Kingsdown near Deal. In Exmouth in East Devon, there are 105 council huts for hire, but these are of concrete, not wooden, construction.

Nestling in
the sand in
Southwold,
England, the
owners of these
huts were
unrestricted
in their use of
colour.

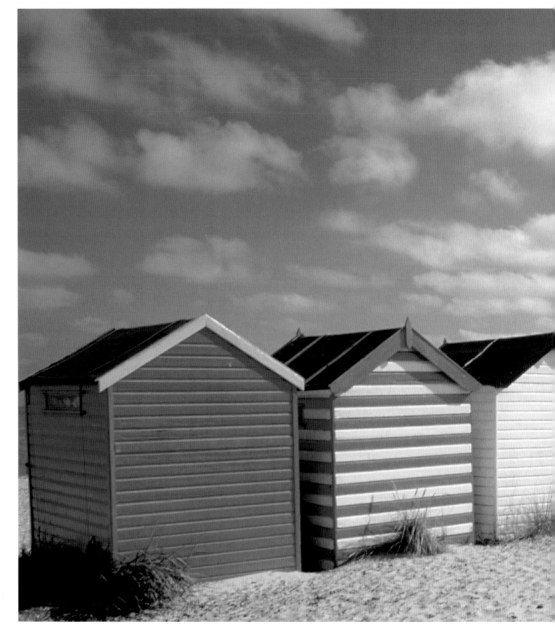

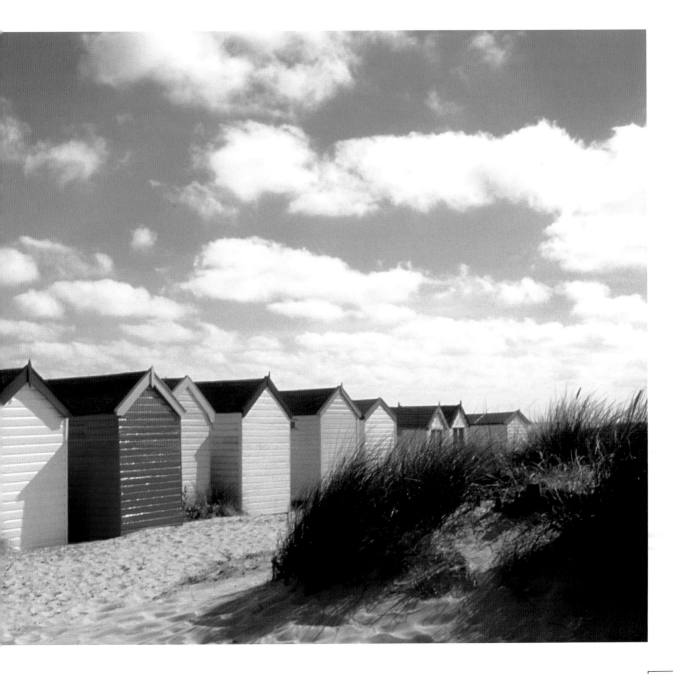

A red and white Kentish beach hut.

The painting of the crown on the fascia boards of this Southwold
hut proves that attention to detail does pay dividends.

Beach hut connoisseurs could scarcely contemplate spending their precious seaside days in a concrete structure; for purists, only natural wood is good enough and, as wood will weather and blend well with its surroundings no matter what colour it is painted, most local authorities insist on wood, too.

Although most British beach huts are wood, the concrete structures at Exmouth are far from unique and exist in clutches all around the country – not for the purist perhaps but they certainly will not blow away in a gale. Farther along the coast, East Devon Council has 38 huts and 80 sites at Budleigh Salterton, where 'hutters' can erect their own huts. At the sleepy little town of Sidmouth, there is an exclusive clutch of 14 beach huts for hire. Although the main town beach is pebble and shingle, the huts are situated to the west on a beach known as Jacob's Ladder where, when the tide is out, there is a strip of golden sand that has made this stretch of Devon shore very popular with families, there being rocks for children to clamber over and rock pools to investigate before rushing back to the comfort of the hut for lunch or tea.

Moving farther east, at Beer there are 39 sites for hire and at Seaton the council provides 74 sites. On this one short stretch of Devon coast, therefore, at least 350 beach huts can be found during the summer. On the Essex coast between Walton on the Naze and Frinton-on-Sea, there are around 2,000 beach huts, sometimes in rows several deep along the sea wall and looking like a giant paint box such is the variety of colours.

It is almost impossible to count exactly how many huts are used each summer around the beaches of Britain, but estimates range from several hundred thousand up to around three-quarters of a million.

One of the best-known concentrations of huts in Britain is at Mudeford Sandbank in Dorset. Mudeford is a small fishing village at the mouth of the River Avon and opposite its harbour, stretching across the estuary, is a long sandy spit of land, Mudeford Sandbank, that has been a perennial destination for beach lovers since the 1920s. A few fishermen's huts stood on the site prior to its colonization by holiday-makers, the largest of which, known as The Black House, has been on the sandbank for over 200 years. Originally a boat builder's house, the wooden building was used to make the 'guinea boats' that were used almost exclusively by smugglers. When a group of smugglers were trapped inside the house by customs men, they refused to come out and the customs officers set fires around the walls. The smugglers soon gave themselves up but the heat and smoke blackened the outside of the building and it has remained that way. Today, The Black House has been converted into holiday apartments and guests are enticed to stay there by the offer of spending their holiday in a genuine smugglers' house.

The famous Mudeford beach huts range along the spit adjacent to The Black House and are far more recent developments. The first leisure hut appeared there around 1918 and, over the next 10 years, huts sprang up in a haphazard fashion until, by the early 1930s, there was a holiday community there during the summer months inhabiting over 100 huts. The Mudeford hutters also enjoyed a privilege not available to most other beach hut communities in that the local authority allowed them to stay in the huts overnight, even though there was, at first, no provision for public lavatories or even a proper water supply.

In the beginning, there was little by way of regulation on the sandbank to prevent people from erecting whatever kind of hut they chose and basic huts were extended by

Not the ramparts of a coastal fortress, just the friendly shadow of beach huts on the sea wall.

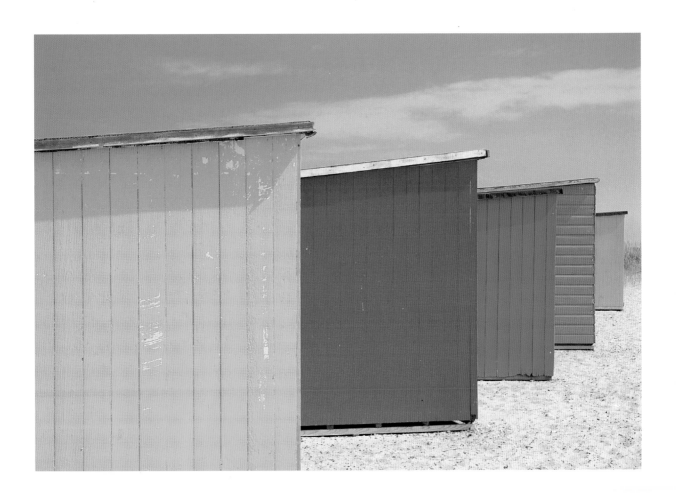

The roofs of these huts in Norfolk, England, are not
pitched with an apex, but slope front to back.

adding verandas or sun decks. Following World War II, enterprising amateur hut builders scavenged materials – timber, doors, even windows – from nearby abandoned military camps to fashion or extend their huts but, by then, as with everywhere else, local authority regulations were becoming more restrictive. Charges were levied for the extra space occupied by 'add-ons' to the huts, although the hut owners eventually reached an agreement with the authorities that a certain amount of space outside the hut could be utilized without incurring excess charges. The local council certainly did not want to discourage holiday-makers from heading for the sandbank, although cars were eventually banned from the approach to the spit where it adjoins Hengitsbury Head. For many years the 'Noddy Train' – a land train of open carriages – has provided access to the beach huts from the Hengitsbury Head car park, but stalwart hutters still prefer to take the traditional route via the short ferry, now known as a water taxi, crossing from Mudeford. Lugging bags of provisions off the ferry and trudging through the sand with them up to your beach hut has, over the years, become a labour of love for hutters that marks the start of yet another idyllic holiday at Mudeford.

Today there are over 350 beach huts of various sizes (only one of which is a 'day' hut) on Mudeford Sandbank. They remain stubbornly anchored to the sand despite the spit's vulnerability to erosion, high tides and storm surges. Christchurch Borough Council, which manages the area, spends a great deal of time, effort and money on measures to prevent erosion, including the recent construction of rock groynes to preserve the sands. Naturally, such preservation work is hugely expensive, but investing local authority money to maintain a local amenity is not only desirable in terms of the council's responsibility for conservation of the countryside, but is also desirable as a means to

promote tourism in the area – it is an investment that protects a substantial source of income. Hut owners pay the council a site rent of around £2,000 per year, working out roughly at a rental income of over £750,000 from the whole community. Add to that the fact that a transfer fee must be paid whenever a hut is sold and the value of the revenue earned from the hutters is easy to appreciate.

One of the reasons that Christchurch Borough Council can justify its hefty site rents (sites in other areas around the British coast can cost just a fraction of the price) is because Mudeford Sandbank is so unique. Huts here have stunning views across the natural bay towards Christchurch Harbour in one direction and out across The Solent to the distant Needles of the Isle of Wight in the other. When hutters first started colonizing the sandbank, many described it as a desert island, such was their delight at finding such a picturesque spot, and the vagaries of the local tides could sometimes mean that the sandbank was cut off from Hengitsbury Head, turning it for a short while into a real island. Their love for the location meant that Mudeford was one of the holiday spots around the British coast where beach huts survived the holiday-makers' rush to the Mediterranean sun and families returned year after year, the huts themselves being passed down from one generation to another. It is not unusual to find huts that have been used by the same family for 50 years or more, and at Mudeford one market research report found that the average occupancy of the huts was 25 years. Since the 1970s, only around a dozen huts have changed hands each year, something less than a 3.5 per cent turnover in ownership. With people hanging on to their huts, or hut sites, acquiring a hut has become a real challenge in recent years and this, inevitably, has pushed up the price.

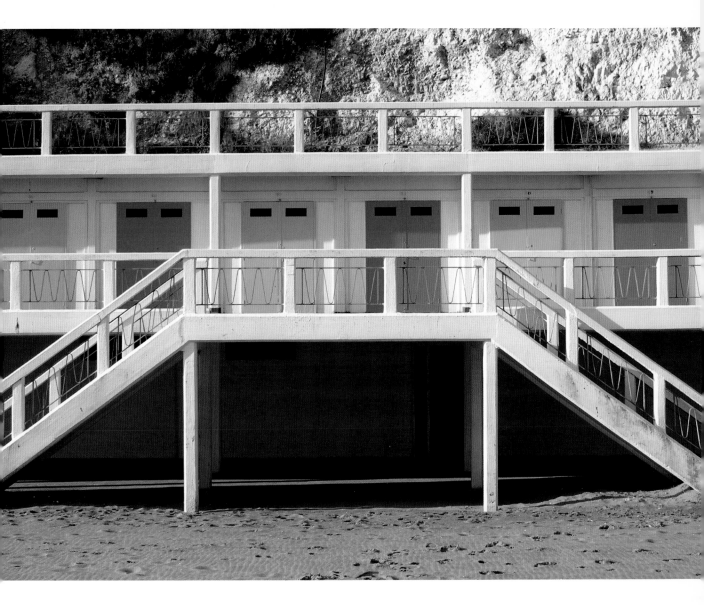

Above: Not for the purists, perhaps, but this hut complex at Broadstairs in England

is still a popular base for beach-loving families.

Opposite: The sky blue of these huts brightens up a grey day in Eastbourne, England.

At Worthing hut owners have watched the value of their seafront huts skyrocket over the past few years, with prices topping £7,000, while at Southwold in Suffolk huts have changed hands for sums ranging from £8,000 to over £40,000. At Hove in East Sussex prices can easily top £8,000, and at Rustlington in West Sussex one hut was recently being marketed at £15,000. Nowhere, however, can beat the asking price for one hut in Mudeford. The 16 x 12ft hut, admittedly larger than most average huts, was advertised as fully furnished with room to sleep at least four people, a gas-powered fridge, gas lights and a 50-gallon refillable water tank. The price? £140,000! Not so far away in the Southampton area that sort of investment could buy you a three-bedroomed house and, if you account for such a price on the basis of cost-per-square-foot, it makes a Mudeford beach hut far more expensive than an apartment in London's exclusive Knightsbridge area. Such prices have certainly tempted some families to part with their treasured heirlooms, but this has not necessarily made renting or buying a hut any easier. Many local councils are determined that the traditional huts should remain under the control of local families. Most of the sites leased by East Devon Council, for example, are only available to permanent residents in the area, and at Hove the council will only issue leasing licences to people who live in the Brighton and Hove district.

# Even if you qualify to lease a pitch, however,

you should not expect to be sitting in a deckchair soaking up the sun outside your own little wooden home-from-home any time soon. So many people want to join the beach hut set that demand for leases far outstrips supply. The majority of councils run waiting lists for those applying for leases, but most of these lists are so long as to become unmanageable and are often closed to new applicants or, in the case of Worthing Borough Council's huts at Goring, only those with time and a great deal of patience need apply. To reach the top of the list for a council hut in Goring would take five years and to lease a space for a private hut at least ten years.

No such restrictions applied to the sale of perhaps the most notorious, and certainly the most travelled, beach hut of all time. This hut had been one among many that graced the seafront at Whitstable, just a few miles along the Kent coast from where the renowned artist Tracey Emin was brought up in Margate. Emin had a close affinity with the British seaside, her mother having run the International Hotel in Margate, where Emin spent her formative years. She gained notoriety for her autobiographical works such as 'My Bed', nominated for the prestigious Turner Prize. This was simply her own unmade bed, adorned with rumpled sheets and dirty underwear. She also exhibited a tent with the names of everyone with whom she had ever slept sewn onto the inside and entitled 'Everyone I Have Ever Slept With'. Given the highly personal nature of her work, it is hardly surprising that when she bought a beach hut in Whitstable along with fellow artist Sarah Lucas, the humble hut was destined to become more than just a seaside bolthole. While Emin used the hut, just as every other hutter does, as a base from which

to enjoy the air, light and space of the seaside, she was also able to find creative inspiration within its simple wooden walls. In stark contrast to those who find happiness and relaxation in the cosy comfort of their huts, Emin used the bland, whitewashed interior of her hut in a rather more disturbing manner. The plain wooden walls became a backdrop for a series of mournful and depressing photographic self-portraits, posed naked and alone, in images intended to be as superficially shocking and psychologically uncomfortable as any of her other work. The hut itself eventually became a work of art, exhibited in the Saatchi collection in London at first entitled simply 'The Hut' and later 'The Last Thing I Said To You Is Don't Leave Me Here'. Art connoisseur Charles Saatchi paid £75,000 for the privilege of displaying the rather shabby and dilapidated blue hut that also crossed the Atlantic, along with Emin's bed, to be exhibited in New York. Sadly, just as it was destined to become the world's most famous beach hut, Emin's 'The Hut' was destroyed while in storage, along with countless other works of art, in a warehouse fire in east London in May 2004.

A work of art it may have been, but Emin's beach hut would have raised a few eyebrows had it remained in situ alongside the other hutters' retreats by the beach at Whitstable. Any art lovers among the occupants may well have understood the message she was trying to convey with her art, but others are likely to have been far less appreciative. People who love beach huts like to keep their huts in the best possible condition. Part of the great attraction of a row of huts nestling near the sand comes from the way they are maintained, standing in regimented rows like sentries guarding the shoreline, their roofs a series of straight lines and their paintwork, albeit rarely of uniform colour, gleaming like the tunics of ceremonial guardsmen. Emin's hut, with its

dingy blue exterior paint faded and peeling, its woodwork broken and split, patched with makeshift repairs, its roof sagging and roofing felt torn asunder, would have had many hutters demanding its removal. The quaintness of a jolly row of beach huts, bright and cheerful in the sunshine, is almost guaranteed to raise a smile from anyone who comes across them. The depressing dilapidation of Emin's 'The Hut' would make it stand out like a blackened, broken tooth.

Most beach hut communities in Britain have formed associations, organizing themselves to help each other maintain their huts and to work with the local authorities to resolve issues that affect the hutters' properties. Local authorities, of course, require that those who own huts or rent council huts maintain them in the appropriate manner. Emin's hut would certainly have fallen foul of the myriad council regulations enforced in most areas of Britain covering the erection and maintenance of huts. At Beer, for example, East Devon Council insists that huts conform to a regulation size – 6 x 8ft in area and 8ft tall. On some of the pitches at Beer the huts can remain on site all year round, but in the majority of cases those lucky enough to have secured a pitch (the waiting list here is also a staggering 10 years) can build their huts in place after 1 May each year but must dismantle or otherwise remove them from the site by 31 October. If you do not have yet another, presumably bigger, hut in your garden at home in which to store your beach hut over the winter, there are enterprising local experts on hand who will help build, dismantle and store your hut for you – at a price, naturally. This may seem like a real headache for owners, but leaving a beach hut on site all winter can prove far more of a problem. In exposed locations, huts battered by the wind during winter storms have been completely flattened or even blown away. Large sections of hut being

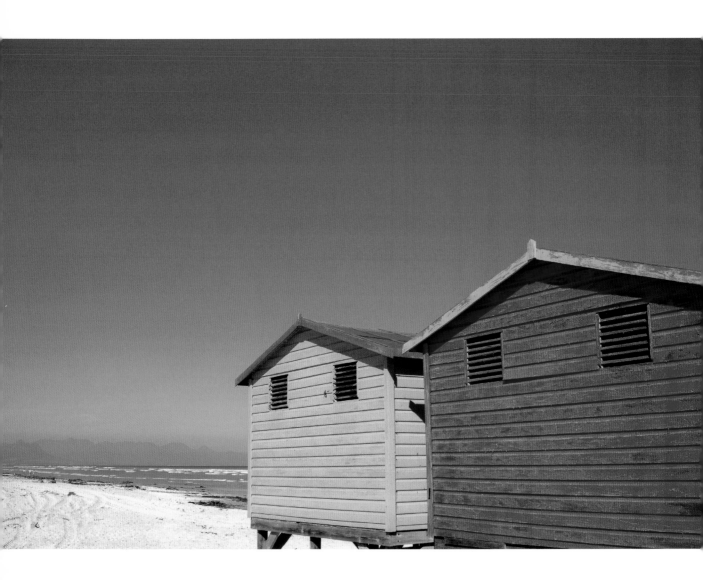

Sunshine will peel it off and wind-blown sand will blast the paint from a hut's woodwork, as with this South African example.

Part-stripped wood can have a rustic charm all of its own,
but really it's time to get the paint brushes out.

propelled through the air by a mighty gale can cause serious damage to other property and serious injury to anyone unlucky enough to get in their way. Getting rid of the hut during the winter months also gets rid of that problem.

At Seaton, huts can be erected from the beginning of April and must be 6 x 8ft with a pitched roof no more than 6ft high with eaves of 1 ½ ft. Here, as at Goring, huts must be painted white. The regulations governing beach huts at Hove state that a hut must be erected on the leased site within three months of the start of the leasing period and that it must be kept in a good state of repair with windows, window frames, hinges, locks, bolts and any other exterior features properly maintained. The hut must be secured against the entry of any unauthorized interloper and, if it is damaged by weather or vandalism, it must either be promptly repaired or removed from the site.

Vandalism is, unfortunately, an all-too-common problem for beach hut owners. Late night revellers meandering along the seafront in many resorts have taken to 'roof walking', hopping from the roof of one hut to another along the entire line of huts. Needless to say, this can cause serious damage to the hut roofs, as well as to the roof walker. Poorly secured huts are also a strong temptation for weary drunks, perhaps caught in a shower of rain on their way home at night. The quiet locations of the huts mean that they are often easy to break into, a warm and dry place to sleep off a night's drinking before moving on at dawn. Sadly, if the weather is not warm, the temptation is to use the ubiquitous portable gas stove that may have been left in the hut or even to light a fire on the floor. Many beach huts are burned to the ground each year and, if there is bottled gas in the hut, a fire can obviously cause untold damage to

neighbouring huts, too. Most councils require as part of the leasing agreement that owners carry insurance against fire, theft and damage.

The council regulations at Hove are fairly typical of those up and down the country. They prevent the licensee from selling the hut to anyone who is not a resident of Brighton and Hove, legislate against using the hut for any kind of business purpose or for storage, forbid the keeping of animals or pets in the hut and bar the owner from placing any kind of advertising on the exterior. Owners are also forbidden from playing or amplifying music or sound that might be heard outside the hut, using the hut as a place to sleep overnight or for any illegal or immoral purpose. They are also warned against indulging in any kind of behaviour that might cause a nuisance or annoy anyone in neighbouring huts or be offensive to passers-by.

All of these rules, and all of the other regulations, are there, of course, to ensure that beach huts are used in the way that they have always been intended to be used: as a traditional family amenity that allows everyone to enjoy the delights of the beach in peace and comfort. None of the rules, judging by the length of the waiting lists for sites in most resorts, seem to put people off trying to get their hands on a beach hut, so it seems fairly certain that, even though prices will fluctuate just as they do in the rest of the property market, people will be buying or renting beach huts in British resorts for many years to come. The huts that were once in danger of disappearing as sunseekers headed abroad for their holidays, now look like they are finally here to stay – at least during the summer months.

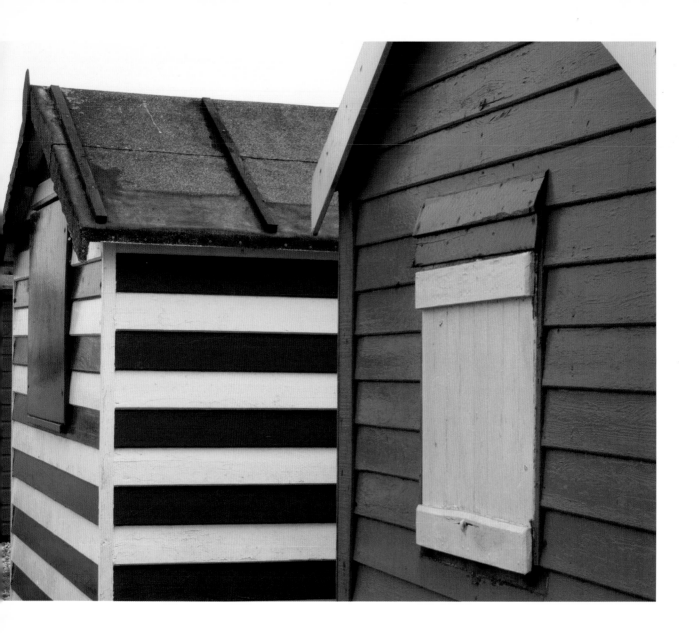

Blue and white or blue and yellow are popular because they are the basic colours of the sky, sea, clouds, surf and sand.

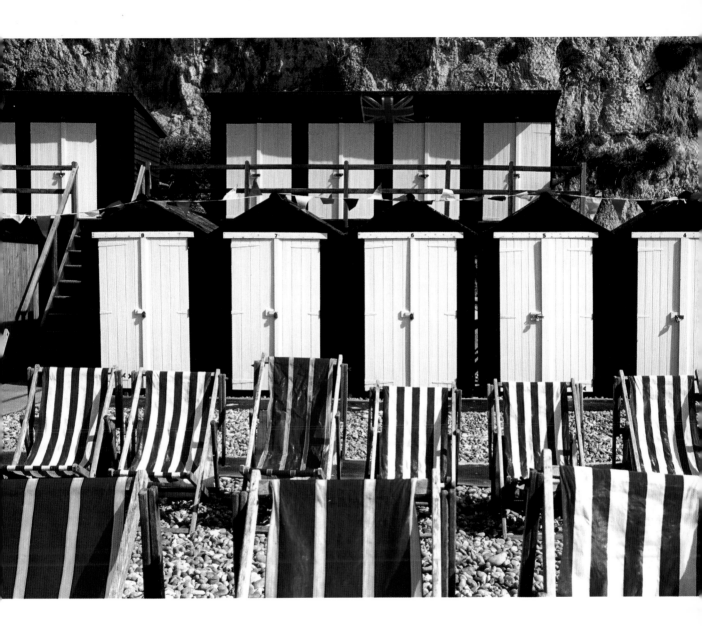

Only the deck chairs' stripes enliven the rather sombre
colours of these huts at Beer in England.

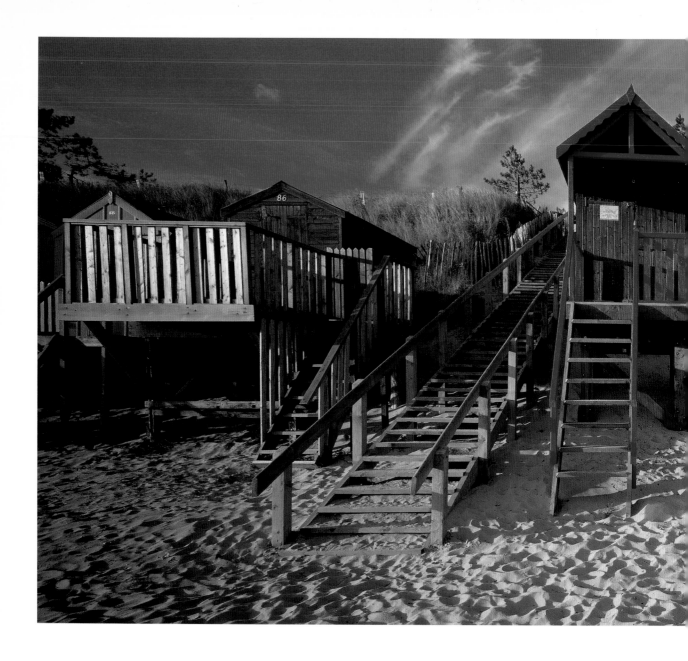

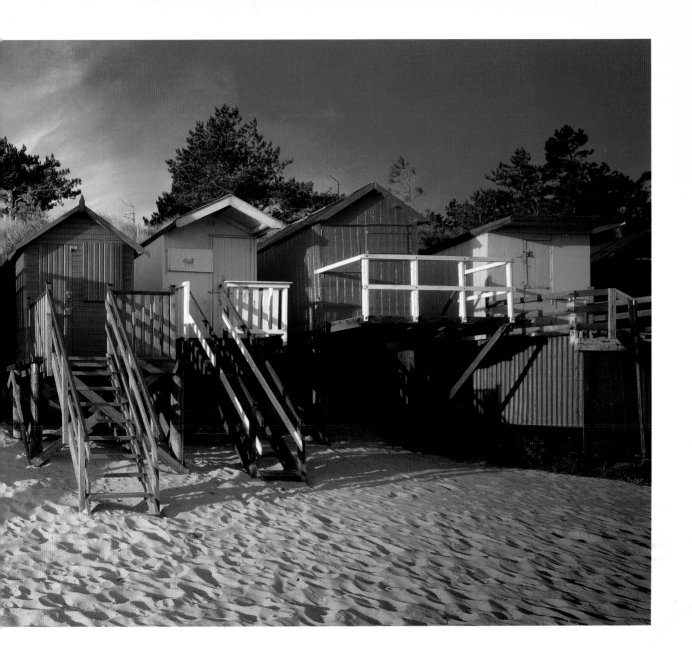

These grand huts-on-stilts are in Wells-Next-The-Sea in Norfolk, England.

Above: These weather-faded American huts form a functional block of changing facilities.

Above right: Bright white huts adorning a Brittany beach in France.

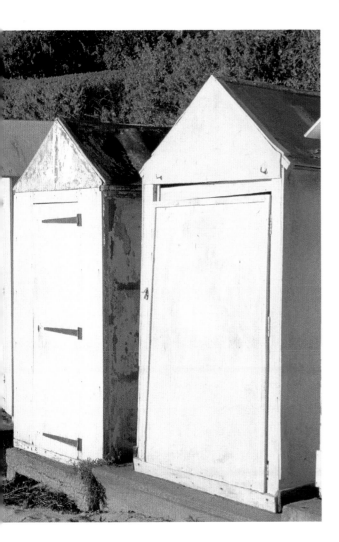

Right: Larger and more luxurious than the average hut, these are Adirondacks cabanas in upstate New York.

# The march of the hut began in earnest in the 19th

century. Although the history of the beach hut is firmly grounded on the sands around the shores of Britain, once sea bathing became fashionable the idea was quickly adopted elsewhere. As in Britain, foreign beach huts owed their existence in many ways to the popularity of the bathing machine. From its humble beginnings in Margate (or possibly Scarborough), the bathing machine rapidly made its mark in popular culture, featuring in William Makepeace Thackeray's novel *Vanity Fair*. First published, as many novels were in those days, in serial form in 1847, *Vanity Fair* is the story of a young woman, Becky Sharp, and her adventures, beginning with her attendance at Miss Pinkerton's Academy for Young Ladies, following her as she makes her way in society. Intended as a satire about social values in the early 19th century, the ridiculous (as they appear to us now) bathing machines certainly merited a mention. Lewis Carroll also referred to bathing machines in his 1876 comic poem 'The Hunting of the Snark: An Agony in Eight Fits', about a group of adventurers searching for a mythical beast. Both references serve to show how well the ubiquitous bathing machine had established itself in the popular psyche and as a part of the landscape in almost every seaside resort. Once it had become fashionable in Britain, it was only a short time before the bathing machine fad crossed the English Channel.

The fashion-conscious French were less strict about the segregation of the sexes on their beaches and were quite daring when it came to swimwear design (the bikini, after all, is a French invention from 1946), but they loved the idea of bathing machines.

This Bahamas hut perfectly matches its surroundings.

# BEACH HUTS ABROAD

The machines flourished on the fashionable beaches of Calais and spread down the coastal resorts from around 1820 onwards. European seaside towns developed in much the same way as their British counterparts, and by 1837 new resorts like Trouville near Le Havre were established, with bathing machines lining the beaches. Over 180 years before the beaches of Normandy would be criss-crossed with the tracks of war machines on D-Day in 1944, French artist Eugene Louis Boudin (from Honfleur near Trouville) showed the sands criss-crossed with the tracks of bathing machines in his painting 'Approaching Storm' that depicted a group of heavily crinolined ladies gathered around a group of white bathing machines gleaming against a foreboding sky of heavy dark clouds. Not only had the French become enamoured of these cumbersome 'Cabines de Bains' but the Germans took to them, too, as did the Belgians. Bathing machines even appeared in a nostalgic illustration on a late 20th-century Belgian banknote, prior to their adoption of the common European currency, the Euro.

The invasion of the bathing machines did not stop on the beaches of Europe, due to the British influence in the 19th century spanning the globe through Queen Victoria's empire of colonies. Where the British went, so too did their social attitudes, including their fixation with bathing machines. The wheeled huts were used in South Africa and in Australia and the trend even spread to the former colony of the United States. As the railroads made American east coast seaside destinations like Long Island Beach, Far Rockaway, Coney Island and Fire Island accessible to New Yorkers, so the 'bathing wagons' began to appear to cater for the influx of seaside holiday-makers. Then, just as the gradual change in attitudes in Britain spelt the end of the bathing machine at home, so the adoption of more relaxed attitudes to mixed bathing and the wearing of swimsuits

that were easier to change into, and out of, made the wheeled huts increasingly redundant throughout the rest of the world. Although some would stay in use, mainly due to their novelty value, into the 1920s, bathing machines gradually disappeared from beach resorts around the globe. In the United States, this did not immediately lead to the establishment of rows of beach hut 'sheds', but on the beaches of Europe – especially in the northern resorts – the wheels came off the bathing machines and the huts were planted in the sand just as they were in Britain.

Nowhere in France is the beach hut phenomenon more apparent than at Calais, where the sand dunes of the beaches near the famous ferry port boast scores of white-painted wooden huts to rival any community of hutters in Britain. Nestling in the shelter of the dunes to the west of the port, the huts can be seen by day-trippers and holiday-makers on ferries entering the harbour and the beach life they represent seems a million miles away from the industrialized areas just a stone's throw away on the other side of Calais. As you travel farther west along the beach, the white huts give way to clusters of more brightly coloured wooden bolt-holes where the hutters are isolated in the dunes, not exposed on a sea wall that might also play host to a promenade populated by strolling dog walkers, or a main road with cars rushing past. The thing that the Calais huts do most definitely have in common with most south coast British beach hut communities is the weather – and that may go a long way towards explaining why such a large congregation of huts has developed. The English coast lies just over 20 miles away to the north, so the weather in this part of France is just as unpredictable as that in England. A day out at the beach is not necessarily a day of guaranteed sunshine, so having a beach hut in which to seek refuge from a summer downpour holds the same attraction in Calais as it does in

most British resorts.

All along the northern coast of France, beach huts can be found hidden away in small sandy bays, but one of the most attractive collections of huts stands on the sea front at Wimereux, just east of Boulogne. Established as a port by decree of the Emperor Napoleon in 1806, Wimereux nestles between outcrops of crumbling cliffs and its sheltered position led to its development as a resort during the 19th century, when many of its grand houses were built. In 1899 the town played a part in the development of radio when Marconi received signals from Wimereux at his receiving station 130km away in Chelmsford, across the channel in England. Today the resort is a bustling seaside town with a promenade and protective sea wall that runs the length of the sea front. At high tide, the waves lap against the sea wall, but when the tide is out, a wide expanse of sandy beach is revealed, making the resort a haven for land yachting, the awkward-looking three-wheeled, triangular land yachts racing across the sand beneath their multi-coloured sails.

Wimereux is also a designated 'Kid Station', a scheme established in France to recommend family holiday spots that are regarded as being particularly safe for children. Up on the sea wall looking out over the activity on the beach and across the channel towards England is a terrace of intricately designed, elegant hotels and residences at the foot of which stand a row of beautifully decorated beach huts. Painted predominantly white, the simple wooden huts with double doors opening onto the promenade have been decorated with blue detailing and seaside motifs such as starfish and sailing boats. One has a particularly nautical theme, featuring a stylized sailing ship in the background of a portrait of Corto Maltese (the name given to the hut). Corto

is a seafaring adventurer created by Hugo Pratt in a classic series of graphic novel comic book stories that first appeared in 1967. Just as bathing machines cropped up in the literature of the 19th century, the literature of the 20th century has featured beach huts.

So many of the small coves along the northern coast of France have beaches of sand or pebbles where beach huts have sprung up that estimating their numbers is as difficult as guessing how many appear on British beaches. In some places there are sizeable communities, while in others there are just a select handful, as at Quiberville just outside Dieppe. Here there are a couple of hotels to cater for the weekend and high-season holiday trade where tourists can watch the local fishermen launch their traditional (if now thoroughly modern, aluminium and motorized) flat-bottomed boats from the pebbles on the beach. The boats are hauled down to the water's edge by tractors today, rather than the horses of old, but tucked behind the roadside stalls, where the fishermen's catches are sold straight from the boat, is a clutch of beach huts. Seemingly at odds with the modern concrete of the sea wall and the sophistication of the small local casino, the wooden huts serve their traditional purpose as a refuge for day visitors, just as the fishermen continue to ply their traditional trade. The proliferation of French huts continues along the country's many miles of Atlantic coastline through Normandy and Brittany into the Loire, Charantes and Aquitane regions, through stylish resorts from Le Touquet to Biarritz, but the 'traditional' wooden beach huts appear more in the north: closer, perhaps, to their English roots. That is not to say that the beach hut has not travelled far from British shores – quite the contrary.

One of the first beach huts ever to grace a stretch of golden sand appeared not

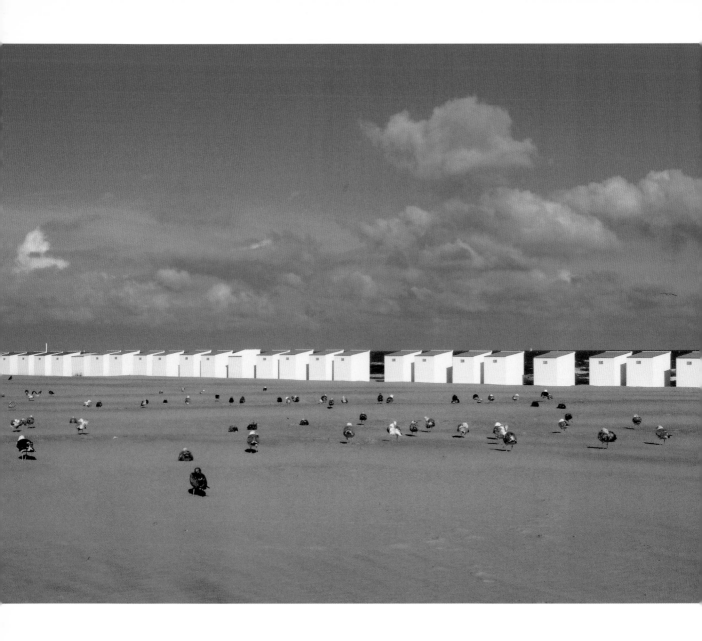

A Belgian beachscape with a regimented line
of sentinel huts guarding the shoreline.

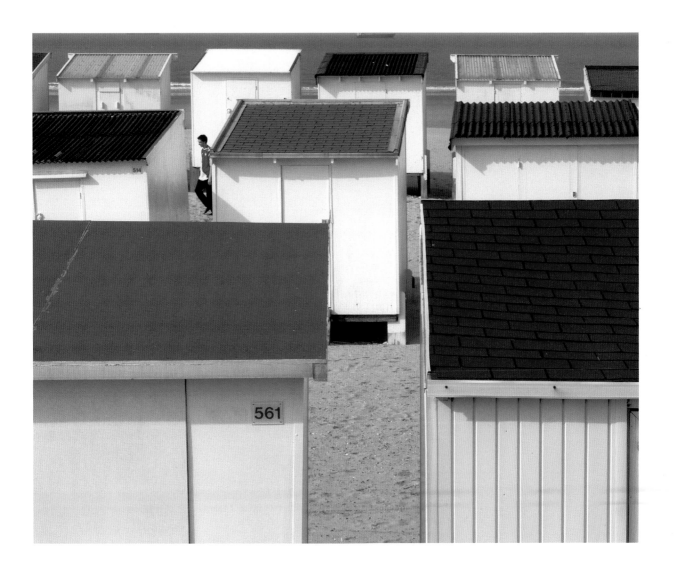

Scores of white huts line the shore on the beach
outside the northern French port of Calais.

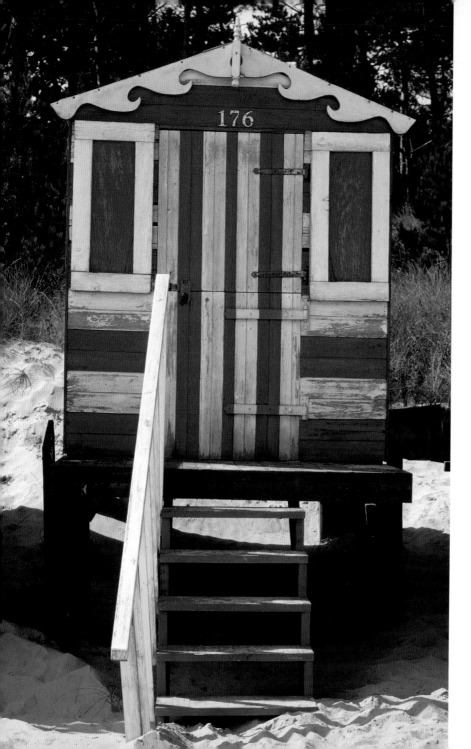

Left: Showing a distinct family resemblance to its bathing machine forebears, this hut stands on the beach at Wells-Next-The-Sea in England.

Opposite top: Salobrena in the Andalucia region of Spain.

Opposite below: These Italian huts, with their covered verandas and banister rails are larger than most found in that country.

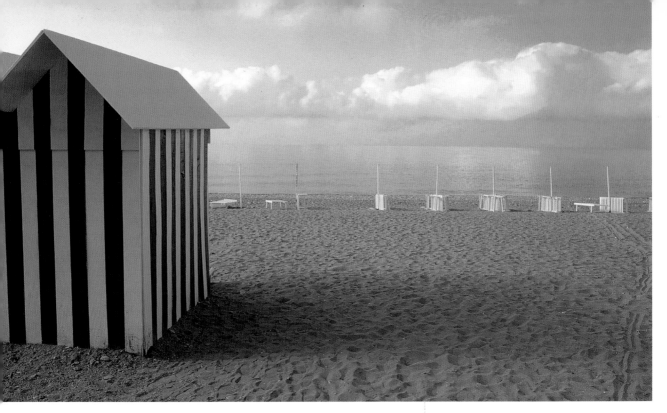

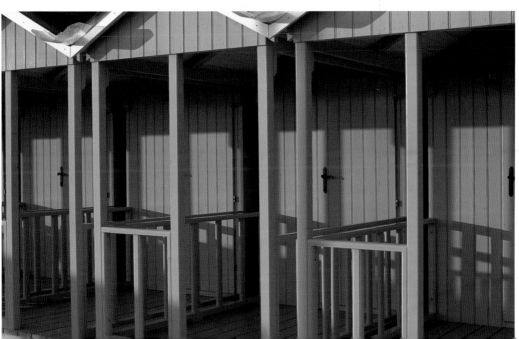

on a chilly seafront in England, but thousands of miles away on the other side of the world. Brighton Beach might sound like it should be washed by the waters of the English Channel, but this stretch of sand is about as far from the Prince Regent's famous Brighton Pavillion as you can get. On the other side of the world in Australia, British settlers took with them British place names to make them feel more at home. Around Melbourne there is a Richmond, a Canterbury, a Doncaster and even a Sandown Park Race Course. There is also a Brighton Beach to the south east of the city and it was here in 1862, when beach huts in Europe were still of the wheeled variety, that an enterprising hutter named Mark Hollow built the beach's first hut. The local authority was none too pleased about it. Mr Hollow may have enjoyed sheltering from the sun or the stiff breeze on his trips to the beach, but he had built his hut without proper planning consent. Nevertheless, he established the cult of the hut in the region and huts began to spring up on beaches all over the area. By the early 1900s, huts were lining the shore along the coast at Hampton, Sandringham, Black Rock, Mentone and Mordialloc. Australian beach culture was then far different from that back home in England – more relaxed and with a far better guarantee of fine weather for a day at the seaside. Being on the other side of the planet, when it is winter in Britain it is summer in Australia, and British immigrants did not take long to realize that their traditional Christmas dinner need not be spent cosseted in a cosy, carpeted front room beside a warming fire. In Australia, you might just as well have Christmas dinner in the sunshine on the beach, and what better way to do it than with the convenience of your own beach hut on hand?

Many of those original beach huts in the Melbourne area were ultimately removed by demand of the local authorities or, as happens all too often to beach huts,

were destroyed by storms over the years, but the community that was established by Mark Hollow is still thriving today. The multi-coloured huts on Brighton Beach – no pale, pastel colours or soft seaside hues here – are still there, resplendent in their strident colour schemes of bold chevron, diamond and striped patterns. They have grown famous enough to have become a local landmark, a tourist attraction in their own right, forming the backdrop not only to happy holiday snaps but also to far more glamorous international fashion shoots. Newly-weds have even opted to pose for their wedding photos standing on the beach with the Brighton huts, often referred to as 'bathing boxes', adding a splash of sunny summer colour in the background. One enterprising Australian holiday company establishing a new leisure and golf resort in the area, Sanctuary Lakes, took the beach hut idea inland, regarding the bathing box as an essential symbol of the Australian beach holiday, and offering its clients the opportunity to lease 3 x 6m wooden huts in which they could keep a small boat, or simply chill out by the lake.

At Brighton Beach there are now around 80 bathing boxes that have been there since the 1930s, and the chances of them ever being removed by the local authority are pretty slim – they have become listed buildings, protected under an Australian national heritage scheme. Needless to say, this has also helped to make them highly desirable, despite the fact that, like most old-fashioned beach huts in Britain, they have no running water or electricity. Rather like acquiring a hut at Mudeford in England, however, owning a hut at Brighton Beach can be hard on your pocket, should you have such a thing in your swimsuit. The cult of the hut and the heritage status of these bathing boxes have pushed prices up to almost unbelievable levels. One hut was recently sold at an auction that took

place on the beach. Although the weather was not on the auctioneer's side, with steady rain threatening to put a damper on the proceedings, there was a good turn-out both of bidders and interested spectators. The starting price for bathing box number 47 was set at a cool (AUS) $85,000, but there was no shortage of takers. Faster than you can say 'But it's only a shed', the bidding leapfrogged its way up to $150,000. The successful bidder was, no doubt, highly delighted and was probably equally aware that the price just paid for the blue and yellow hut could have bought an apartment in nearby St Kilda or a four-bedroomed home in the Melbourne suburbs, but such is the attraction of the much-coveted Brighton Beach bathing boxes to Australian beach lovers.

Like Australia, South Africa has past links with Britain that have left their mark. A small but colourful part of its colonial legacy stands on the beach at Muizenberg on False Bay. Taking its name from the fact that many years ago ships coming from the east bound for Cape Town would drop anchor here, mistaking it for Cape Town's Table Bay, the east coast currents make the False Bay shallows far warmer than the Atlantic waters of Table Bay. This helped to make the former military base of Muizenberg a popular seaside destination for wealthy Capetonians at the beginning of the 20th century. The building of the grand mansions along Muizenberg's beach promenade coincided neatly with the rise in popularity of the humble beach hut and False Bay can, therefore, boast an enviable collection of multi-coloured Victorian beach huts that, like those of Melbourne's Brighton Beach, have featured in countless photo shoots. Today only 20 minutes from Cape Town by car or train, the False Bay beaches are popular with surfers, the warm water is safe for swimming and for hutters, and the spectacular ocean and mountain views are supplemented by an added attraction not generally

available to their contemporaries in Whitby or Whitstable: at the right time of year you can not only bask in the sun but also keep your eyes peeled to spot the occasional passing whale.

Although it borders the Zanvei Nature Reserve, Muizenberg's proximity to Cape Town makes it very much a cosmopolitan resort. But if you really want a secluded beach hut that takes you back to nature, Australia can offer a tempting option. On the other side of the country from Brighton Beach, the Cobourg Peninsula reaches out towards Indonesia from the Northern Territory. The area, comprising the Gurig National Park and the surrounding waters of the Cobourg Marine Park, is sparsely populated, unless you count the dolphins, sea turtles, dugong and crocodiles. These are all protected species, of course, although the indigenous Aborigines are permitted to hunt them for food using traditional methods, including spears.

Fewer than 2,000 visitors arrive in the area each year, most of them to fish for some of Marine Park's 250 known species, such as Spanish mackerel, barracuda, barramundi, golden snapper or coral trout. If you fancy a spot of tropical fishing, of course, where better to stay in a veritable paradise of beaches than in a beach hut? This is where the beach hut ceases to be something that looks like it might have disguised itself with a jolly coat of paint to escape from an urban gardener's vegetable allotment, and starts to become a little more exotic. There are only a select few huts available on the Cobourg Peninsula and, although they are variously described as providing basic or even 'rustic' accommodation, they incorporate luxuries that would be the envy of a hutter in Bournemouth or Bognor. With solar power, a permanent (bottled) gas stove and a fridge, a bush shower and a compost toilet, these huts are designed for more than just

an afternoon at the beach. They do, however, represent only the first stage of the beach hut's metamorphosis into truly luxurious holiday accommodation. The next stage is just as tropical, but is the destination for a holiday-maker looking for something with a south sea atmosphere, yet the comfort of a high-class hotel. There is no way the allotment shed could pull off its masquerade in such exotic company.

Much of the charm of the beach hut is in the way it looks. It is the simplest of structures, built in a manner that makes its method of construction entirely obvious. Not for the beach hut the complex of wooden beams that give a timber-framed house its strength, or the cleverly concealed steel framework that allows a skyscraper to soar up into the heavens. A beach hut looks like something you could knock together yourself in half a day. Looks can be deceiving, however, and that is certainly true when it comes to some of the most desirable holiday accommodation on some of the world's most idyllic beaches.

The Maldives is a nation of coral islands sprinkled in a line south of India and running roughly north to south through the Indian Ocean, practically on the equator. Here there are the kind of beaches where you can indulge your most repressed Robinson Crusoe fantasies. Fine, dazzlingly white sand fringes most of the islands – there are around 12,000 of them – with dense tropical vegetation carpeting their interiors. The crystal clear blue waters are famous the world over for scuba diving and snorkelling. Breathtakingly beautiful, none of the islands rises more than about 2m out of the water, and only about one in ten of them is permanently inhabited. Of those, less than half have been developed for tourism, and even then there is generally room for only one hotel or complex. Even the islands' capital, Male, has to have its international airport on a

neighbouring island. On these paradise islands stand some fine examples of what some would regard as the ultimate beach huts. While there are many luxury hotel complexes and bungalow developments scattered throughout the Maldives, the accommodation of choice for upmarket hutters is, naturally, a hut on the beach that has the essential charm of looking like a weekend's work by a competent handyman.

At Komandoo, on Lhaviyani Atoll's north-west reef, for example, the wooden huts – admittedly larger than the average British beach hut – with the natural colour of the planking used for their walls and the darker-stained, pitched roof planks blending in serenely with the lush greenery that forms a shady curtain along the shoreline, look like something an enthusiast might pick up at his local DIY superstore as a project for a slack Sunday afternoon. On closer inspection, however, you might notice that the huts, actually referred to as beach villas, are fashioned in the shape of a shell and, when you step inside you would immediately notice that they are air conditioned and elegantly furnished. They are also equipped with telephones, refrigerators, CD players and bathrooms with walk-in showers. This is luxury accommodation, not just somewhere to brew up a pot of tea on your camping stove.

You could be forgiven for thinking that the more basic looking, native-style constructions built on stilts at the end of a pier out over the water might not enjoy quite the same standards as the villas at Komandoo. After all, they are attached to wooden posts driven into the sea bed, their walls are of bamboo, reed or palm leaf matting and their roofs are thatched with reeds or palm leaves. Surely this is pretty basic stuff? You could be forgiven for thinking it, but you would still be wrong. At Rangalifinolhu Island's Hilton Maldives resort, some of the simple-looking huts out over the water have jacuzzis

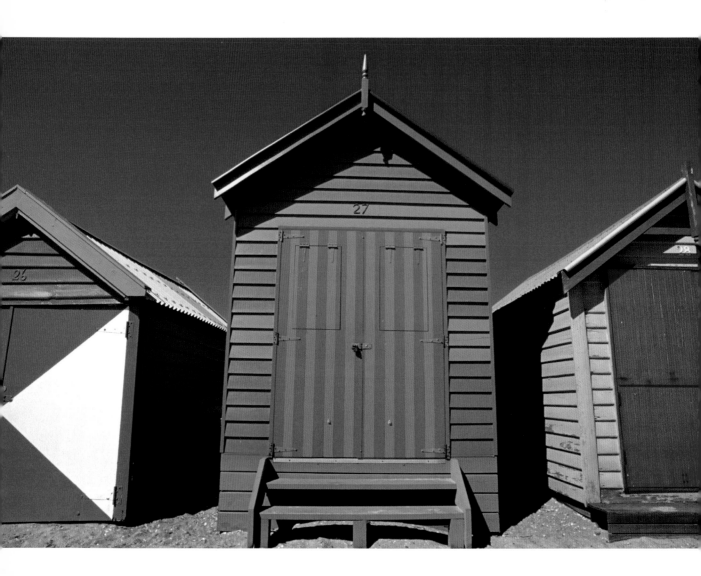

built into their decks, air conditioning, mini-bars, espresso machines and a host of other luxury facilities that even stretch to plasma TVs with DVD players. Huts like these often also have steps leading down into the ocean for your morning dip, although walking down the wooden steps into the warm water of the Indian Ocean under a tropical sun is bound to be a somewhat different experience than that enjoyed by those who walked down the wooden steps into the decidedly chilly water of the North Sea from their bathing machines at Margate.

There are, of course, far less sophisticated versions of the same basic 'exotic' style of beach hut. It stands to reason that in tropical regions, dwellings that are built using materials that fall easily to hand are going to look pretty much like variations on the same theme, just as a beach hut in Cornwall is going to be recognizably the same species as a beach hut in Calais. As a result, the thatched wooded hut proliferates on beaches throughout the Indian Ocean, Thailand and Indonesia, following the equator round into the Pacific.

These Australian huts can trace their heritage all
the way back to the first Ozzie hut in 1862.

# The cult of the tiki hut has its roots in the Polynesian

islands of the Pacific. Tiki, in fact, means god or, in Maori folklore, the reproductive powers of the god Tane who was the creator of the first woman. It can also be taken to mean the first man or the spirit that created the first man. Although it might seem strange that a word with such strong religious connotations should be associated with beach huts, the word 'tiki' has been applied as a collective term for many things of far lesser significance than the gods of the Polynesian peoples.

The word became enshrined in popular culture when Norwegian explorer, archaeologist and anthropologist Thor Heyerdahl created a sensation by sailing a balsa wood raft across the Pacific. Along with five companions, he traversed 4,300 miles of ocean to reach the Polynesian Raroia atoll from Peru in 1947. Having developed a passion for the South Pacific islands when he first visited Tahiti with his wife in 1937, Heyerdahl's academic research convinced him that, contrary to the accepted theory that the inhabitants of Polynesia had originally come from Asia, the ancestors of the island people who had befriended him actually came from North and South America. The only way to prove this was possible was to make the journey in the same sort of craft the sailors in ancient times would have used. He named his raft Kon-Tiki, meaning sun god.

Proving a historical link between the Americas and the romantic tropical islands of Polynesia (with an Oscar-winning documentary film about the voyage helping to maintain its public profile) nurtured a blossoming American interest in the culture of the South Pacific Islands. American servicemen returning from the Pacific after the Second World War brought with them stories of the beautiful people (well, women really) who lived life in a paradise so vastly different from the steel mills, car plants, office blocks and

**Huts on the water in Tahiti, from where the 'tiki' cult emerged.**

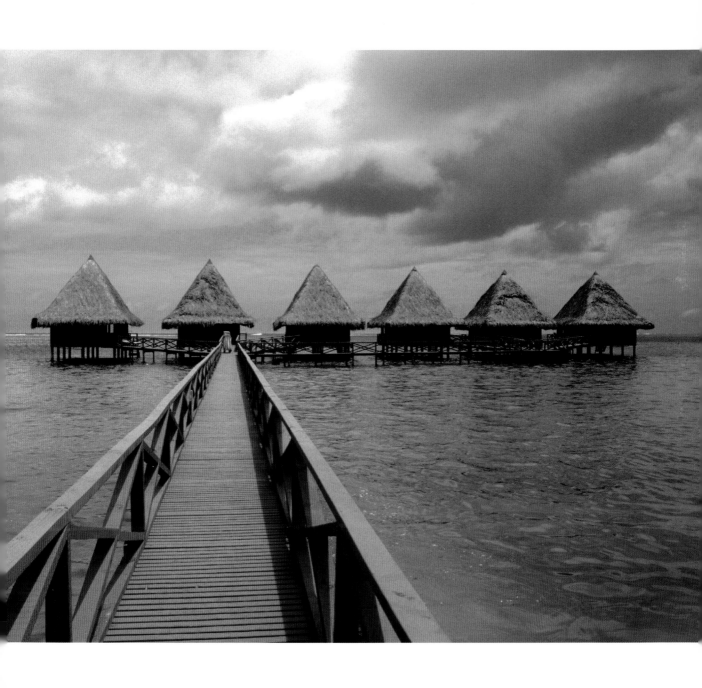

concrete canyons of the cities back home. In 1949, the hit Broadway stage show South Pacific elevated America's interest to new heights, especially when the subsequent movie version became a box office blockbuster. But it wasn't only stories of island life that returning GIs brought home, they also brought souvenirs. Their keepsakes included carved wooden heads, some rather grotesque, some quite comic, of Polynesian gods – the tiki. Some of the traditional carvings and designs were reminiscent of Native American Indian art, making them seem at the same time familiar and intriguingly exotic. The tiki style was soon being applied to goods of all different shapes and sizes. There were tiki ornaments, masks to hang on the wall, mugs, photo frames, decorative bottle corks, butter spreaders and salt and pepper shakers. Tiki quickly became a buzz word, leaping the seemingly unbridgeable gulf between reverent religion and brash popular culture. The word that had once meant god took on a dubiously decadent new aura with tiki bars opening serving tiki cocktails and playing tiki music.

But what should a tiki bar look like? Naturally, it had to be festooned with tiki imagery and have the feel of the South Pacific, so harsh neon lighting, polished glass and chrome were out. Rustic wood and palm-thatched ceilings were what was required – a romanticized version of a Polynesian village hut. And if you can decorate a bar in a tiki beach hut style, why not have your own tiki beach hut at home? The term 'hut' can often be only loosely applied in the tiki context, as can the term 'beach'. The tiki hut craze was as much for pool-side shade as it was for a beach refuge and they came in every configuration imaginable from a simple, palm-thatched umbrella sun shade to full-blown pool house guest quarters. In America today you can buy tiki huts for self assembly or hire the services of professional tiki hut builders who will fashion a tiki shelter for al fresco

dining, a thatched pool bar for outdoor refreshments or a store room for garden or pool equipment. In the majority of cases, of course, these will be huts in a domestic rather than a seaside setting. Tiki huts have migrated from Polynesian beaches (where they are also known as 'fales') to US back yards but in recent years, on different shores, there have been moves to uproot them from the pool surround and plant them back in the sand.

Although many travel companies today offer holidays to Hawaii, Tonga, Fiji, Tahiti and many of the other constellation of Polynesian islands (there are over 100 in the French Polynesian group alone) with accommodation in tiki huts or fales, for those who want a taste of the South Pacific beach hut life without travelling quite so far, holiday villages of tiki-type huts have sprung up all around the Mediterranean. At Cefalu in Sicily for example, there are around 500 beach huts set amid a forest of flowering shrubs and natural greenery on a headland looking out over Cefalu town. These are, quite deliberately, a far cry from the luxury of the beach huts in The Maldives and provide quite basic accommodation. There are no en-suite bathrooms here, but communal washing facilities – you even have to bring your own towel. The thatched huts have electric lighting, but there are no locks on their doors, so if you want to lock up you have to bring your own padlock. There are even huts in the Mediterranean now where a padlock would be superfluous as they have neither a door nor walls. These are truly basic interpretations of the Polynesian fale – just a raised sleeping platform beneath a thatched roof. Definitely not for anyone who might be bothered by the odd mosquito.

These straw huts are certainly a way of enjoying life on the beach and breathing in all that wonderfully fresh sea air – there's nothing like doing away with the walls to let a breeze blow through – and in providing basic seaside accommodation for beach lovers

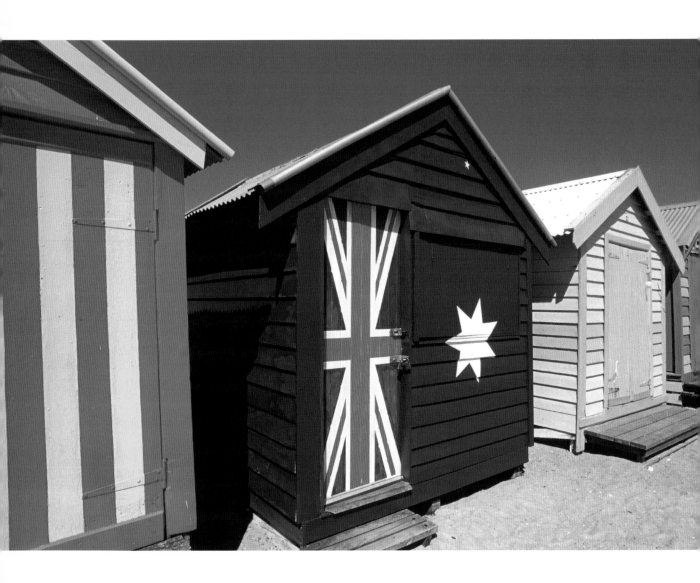

If you didn't know these huts were in Melbourne, Australia, you could probably guess.

Painted as hot as its climate, this hut is on the
Caribbean island of Aruba.

they do have something in common with the traditional wooden beach huts in Britain. The tiki or fale-style huts are also made from natural materials – wood, bamboo, palm leaves and suchlike but, just as the concrete council huts for hire in Exmouth back in the UK don't quite fit the bill for the purist hutter, neither does a tiki. If your idea of the ideal beach hut is somewhere to fold up your deck chair at the end of the day, somewhere to keep your beach toys, air bed and bucket-and-spade overnight, or somewhere you can wriggle into your swimsuit while preserving your modesty, then you wouldn't expect Sicily could provide the sort of hut you've come to know and love. Think again. Italians love their beach huts.

In a picturesque bay where the warm, shallow waters of the Tyrrhenian Sea caress the Sicilian shoreline between Mount Gallo and Mount Pellegrino just north of Palermo lies one of the most elegant resorts in western Sicily. Mondello is a former tuna fishing port that was turned into a garden city tourist resort at the beginning of the 20th century. It seems completely incongruous that the Sicilians who, perhaps even moreso than other Italians, are renowned for their gregarious nature, their ebullient gestures and extrovert temperament, should adopt the same prudish attitude as the British when it comes to changing for the beach, but in Mondello there are neat rows of red-roofed, yellow-and-blue painted wooden beach huts for exactly that purpose. Maybe the highly style-conscious Italians feel that the inelegant transition from chic promenader to bathing beauty should be achieved out of sight, preserving both dignity and public image. Maybe Italian ladies feel the same. More probably the strong Catholic values instilled throughout the country have had the same effect as the Victorian-age values in Britain. No matter how skimpy your swimsuit, you shouldn't put anything on public display that

you didn't intend the world to see in the first place. Whatever the reason for their existence, beach huts are a feature of Italian seaside resorts not only in Sicily, but on the mainland, too.

Between the Golfo di Salerno and the Golfo di Napoli on the western coast of Italy is a peninsula that stretches from Salerno out towards the magical island of Capri. This stretch of coastline, with its vineyards, citrus trees and olive groves, is one of the most scenic in all of Italy and Capri is, of course, famous for being the favourite of the rich and famous. In the year 32 AD, the Emperor Tiberius decided he liked the island so much that he moved to Capri from his palace in Rome. Almost two thousand years later, British singing star Gracie Fields moved to Capri from a flat above a chip shop in Rochdale. Throughout its history Capri has been the playground of politicians, statesmen and pop stars. While it is difficult to compete with Capri in the glamour stakes, the peninsula does offer other world-famous resorts such as Amalfi, Positano and Sorrento. Sorrento is the largest of these resorts and lies not on a sandy beach as one might expect but, in the main, 150ft above the shore on the clifftops. Many of Sorrento's elegant hotels played host to the grand tourists of the 18th century and when holiday-makers tire of browsing around the shops in the narrow streets of the old town they can take a public elevator down through the cliffs to the sea, although some hotels do have their own private lifts and the more energetic can walk down a stepped pathway. At the foot of the cliffs you can swim in the Bay of Naples from jetties over the water, but you probably wouldn't want to make the journey from the hotel to the water in your swimsuit. Where better to change than in a beach hut? Rows of changing huts are available at the water's edge for bathers, providing a facility that is common to a host of resorts in Italy.

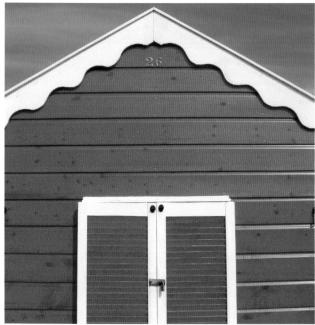

Left: Shutters closed, this hut appears to be snoozing.

Below: Inside looking out onto the Caribbean Sea.

Opposite: City life can seem far away when tucked away in a beach hut. These overlook False Bay in St James, Cape Town, South Africa, where the occasional passing whale can be spotted.

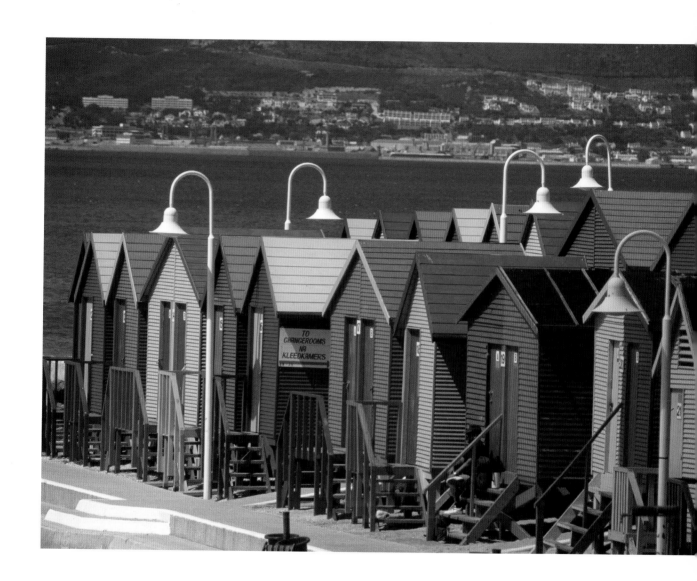

The Italian concept of the beach hut is somewhat different to that in the UK. In Italy, rather than the beaches and the huts that stand on them being owned or run by the local authority, it is quite common for stretches of shoreline to be owned or leased by hotels that may be quite far removed from the sea. For the convenience of their guests, they provide beach huts as changing facilities, or have an arrangement with the proprietors of the huts for hotel guests to use them. Alternatively, bathing beaches, or different sectors of the shoreline in a resort, may be run as business concessions offering the daily hire of sun shades, loungers – and beach huts. Holiday hotels will often recommend certain beach concession areas with which they have arranged for their guests to have special discounts on the hire of beach huts for changing. Some such huts are little more than sentry boxes with very little elbow room for struggling into your swimsuit, smaller than the average changing room in a clothing store and enough to tax even Superman's dextrous phone-booth quick-change act.

Rimini, on Italy's Adriatic coast, has scores of such huts. The resort developed as a sea bathing centre in the middle of the 19th century and blossomed as a tourist destination in the early 1900s when it became known as the 'city of small villas'. Although there are still many ancient buildings of interest in Rimini, much of its rich cultural heritage was lost when the whole town was extensively damaged by heavy fighting during the Second World War. This afforded the opportunity for major redevelopment all along the shoreline which is now famously populated by high rise holiday hotels that look out over the wide promenade where there are orderly terraced rows of beach huts. The huts stand on the promenade and are painted mainly in soft sea shades of blue or green, each numbered squadron of huts occupying its own pitch on the promenade. Down on

the beach there are regimented rows of sun shades in colours to match the sector of huts to which they belong so that sun lovers always know they are in the area of the beach they have paid to use. Closer to the water's edge, the beach is generally free for all to enjoy. But having the use of a beach hut in a resort like Rimini does not pay dividends in the same way that it does in a British coastal resort.  The huts are of a size that would be acceptable even to the most ardent traditionalist among the British beach hut fraternity, but these are not regarded as an extension of your home or holiday accommodation. You don't sit outside these huts enjoying the sunshine, that's something you do down on the beach itself. As changing facilities, however, they are first rate, with most of the beach sectors also offering showers with hot water, play areas for kids and even colour-coded bracelets for children to ensure they are returned to the right sector should they wander off and get lost. The highly organized nature of the beach scene in resorts like Rimini may not be to everyone's taste, but there is no denying the Italians' passion for their beach huts.

With both the British and their mainland European neighbours having developed such an affinity with the simple wooden structures on the beach, it is hardly surprising that when they travelled far afield, they took the idea of the beach hut with them. Huts recognizably similar to those like the striped huts that can be found on the beach near Naples, or their rather more reserved cousins in Cornwall, can also be found on Caribbean islands like Aruba or Antigua as well as the beach resorts of the USA.

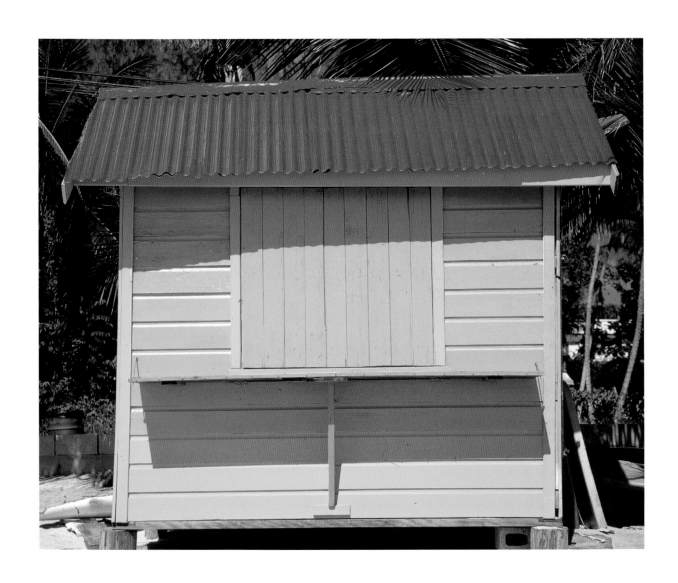

Who says corrugated iron is ugly? Paint it red and it will look perfect on even the brightest of West Indies beach huts.

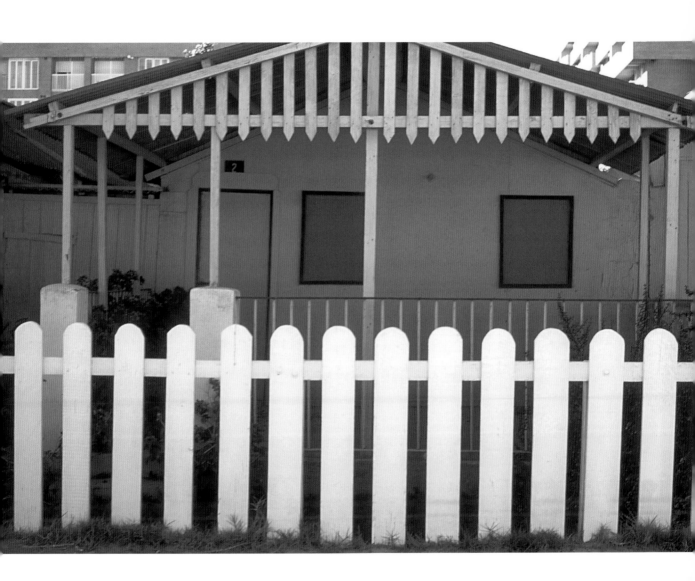

Larger, cabin-style huts can be found all around the world,
these ones are enjoying the sunshine of Valencia in Spain.

American changing huts with the twin architectural merits of style and functionality.

Billionairess Doris Duke proves there is glamour in beach side facilities, at Bailey's Beach,

Newport, Rhode Island, 1934.

The names of film stars attest to the glamour of these
Normandy changing huts.

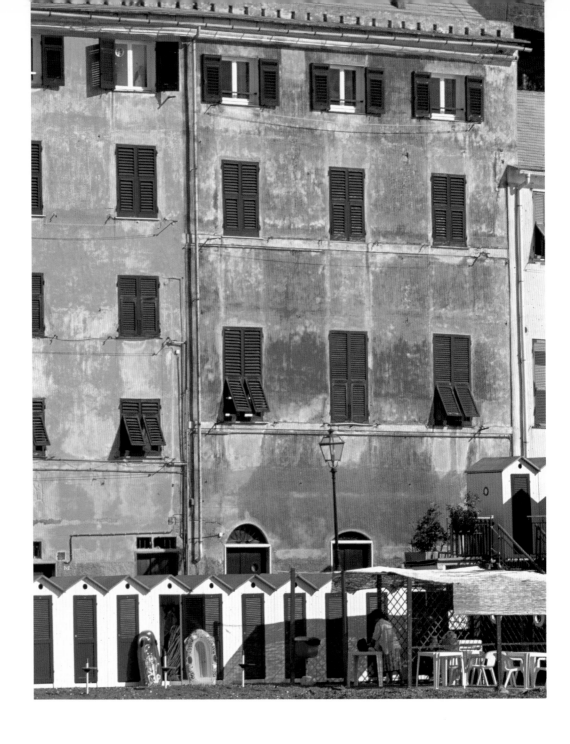

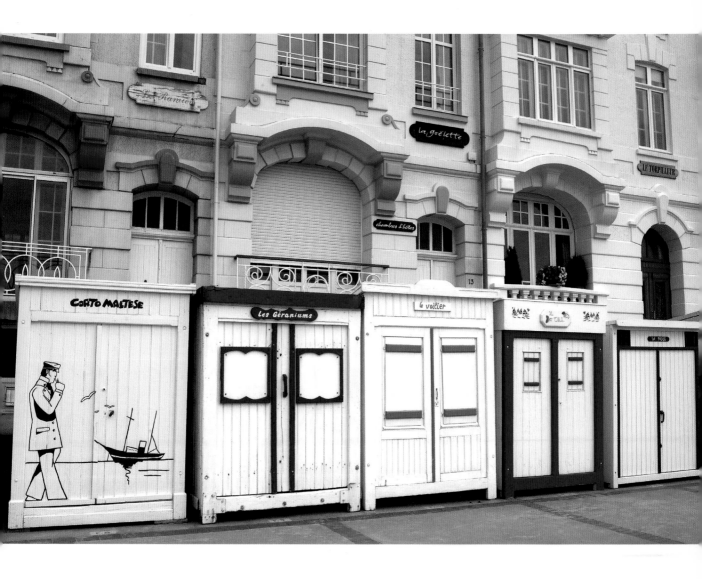

Above: Beach huts on the promenade at Wimereux in France with the comic book hero Corto Maltese decorating the one on the far left.

Opposite: Although slim enough for only the most svelte of Italian bathers to change in, these huts demonstrate their usefulness as a store for beach toys.

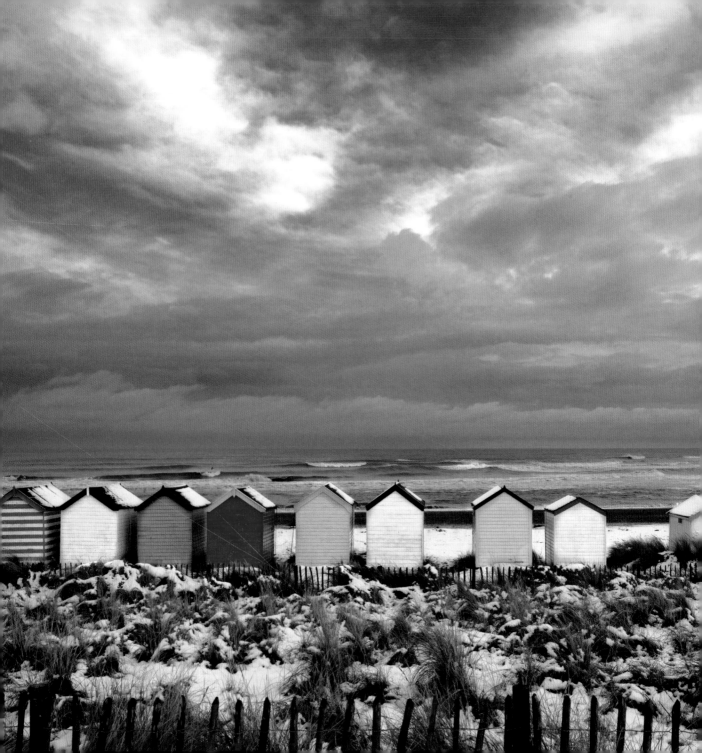

So you've secured your 'pitch' from the local council, having survived up to ten years on the waiting list, and signed the lease promising not to turn your beach hut into a warehouse, nightclub, casino or brothel – what comes next? Obviously, if there is not already a local authority hut on the site, or if you have not already remortgaged your home and sold your least favourite children into slavery in order to buy a hut from its existing owner, you're going to have to find a hut from somewhere. Where do you start?

The local authority, having stipulated the exact dimensions and style of the structure you are permitted to erect on your pitch, will generally be glad to point you in the direction of a supplier or manufacturer who can provide the sort of hut they would prefer to see on the site, although they will usually stop short of actually recommending a private company as that can get them into all sorts of legal liability wrangles. Alternatively, the beach hut association whose members own the huts adjacent to your pitch will be able to give advice on where to acquire your hut. You can also pop into your local DIY superstore or garden centre and start researching the types of hut or shed on offer from companies that manufacture garden sheds and summerhouses. Of course, for the computer literate, the internet is always there to help you find exactly what you're looking for, too. As a rough guide, a basic wooden beach hut will cost from around £1500 with prices rising according to the size and complexity of the design. Most suppliers offer an on-site service for the erection of your hut – a good option if the only nail you are prone to hitting with a hammer is the one on your thumb. Ideally, you will have done all of your research well in advance and pre-ordered your hut so that you are ready to accept delivery of it on site as soon as the pitch becomes available to you.

The huts at Southwold in England shiver
in the cold under a foreboding sky.

THE JOY OF HUTS

Before construction can begin, however, you have to prepare the site. The ground on which your hut is to stand must be level, otherwise you will end up with a sloping floor, which in turn will mean that the walls won't fit and you won't be able to get the roof on. Creating a level pitch is clearly not going to be a problem if your hut is to stand in an orderly line alongside a row of neighbours on a paved seafront promenade, or an area of beach that has been laid with flagstones specifically to accommodate a beach hut community, as the concrete paving will already be reasonably level (save for the camber that allows rainwater to run off). If, on the other hand, your hut is going directly onto the sand or pebbles of the beach, you may have some work to do.

If you are in any doubt about how best to level your site, check out how your neighbours have coped. Beach huts seldom appear anywhere in complete isolation, so there are bound to be other pitches close to yours. Perhaps they have laid their own concrete patio slabs as a base for their hut, or maybe the bearers – the wooden beams or sometimes railway sleepers across which the floor joists of your hut will rest – are sitting directly on the sand. Sand does, after all, make a very good foundation for all sorts of building projects. Unlike the soil in your garden, sand doesn't contain much organic matter and doesn't retain water. Ordinary soil will tend to settle as any organic element decomposes or as it dries out and will become soft and soggy when it gets wet. Sand, on the other hand, will not settle or shrink once it is packed down and drains very well. These are just two of the reasons why paving or patio slabs are commonly laid on a bed of sand. Providing the sand on your pitch is well bashed down and compacted, and is not likely to shift beneath your hut, you may have a minimum of work involved in raking flat a level base.

In some cases, of course, as at Mudeford, Muizenberg, Whitstable and in countless other beach hut communities, the huts actually stand well clear of the sand on wooden posts or legs. Driven deep into the sand, posts such as these are specially treated to make them highly resistant to water penetration, thus helping to stave off the onset of the dreaded rot. Raising the hut a couple of feet off the ground also allows for an exceptionally good flow of air beneath the floor. This dries out the floorboards after the wet, sandy feet and swimsuits of changing bathers have dripped on them from the inside, or rain and sea spray have been carried in on the wind from the outside; dry boards again being less susceptible to rot.

Those exotic huts out over the water in The Maldives are built on piers of decking that are supported by posts driven into the sea bed. These posts will generally be of hardwood that is particularly dense and, even without special chemical treatments, is naturally rot resistant. The posts hold the decking above the waterline, although the occasional soaking from a particularly determined wave will soon dry out in the sun and the sea breeze. Keeping your hut floor dry and clear of potential damp on the ground is also the job of the bearers that will be laid below your hut. The types of fungi that attack wood, eating the cellulose in the fibre of the wood and causing it to lose its strength and become spongy – and you to fall through the floor – need the wood to be quite wet in order for them to thrive. Keeping your floor dry means it will last longer. Before laying the floor down on the bearers, however, there is another precaution you can take. Treat the underside of the floor with wood preservative. Painting on any kind of proprietary preservative is going to be a far easier job before you lay the floor down and build the shed on top, unless you happen to be a world champion limbo dancer – and even then

crawling around under a shed, no matter how much space you might have is never going to be a pleasant experience. So treat the bottom of the floor before it disappears from view.

Before you go any further, some local authorities will insist that your hut is anchored to the ground. That may mean bolting the bearers to the concrete of the promenade and screwing the floor joists to the bearers, or even anchoring the entire shed to the beach using special land anchors or pegs. All in all, it's a sensible precaution. A wild wind can, and has in the past, blown beach huts off the beach or sea wall and into main roads or other people's property, causing extensive, expensive damage. This tends to happen when the huts are unoccupied, of course, but anchoring the hut is a good idea unless you want to become the first hutter to follow Dorothy to the Land of Oz. Again, the best advice is to ask for advice. If the local authority doesn't insist that you secure your hut firmly to the ground and none of your neighbours can ever remember a hut in the area taking off, or meeting a tin man, a scarecrow and a cowardly lion, your hut will probably stay just where you left it for as long as you want it to.

Once you have the site level, the bearers down and the floor treated and laid, it is a simple matter to follow the supplier's or manufacturer's instructions and build the hut yourself. Don't. Putting together a hut where the floor, walls, roof, doors and windows have been supplied ready to assemble is not a difficult job, but it's not a job you should attempt yourself, on your own. Even the smallest of huts is best built by two people, not one. Holding a wall steady, straight and in position while attempting to attach it to another wall that's struggling to go to ground so much you would swear it thought it was a floor, is no job for a human born with only two arms. The manufacturer's instructions

will, doubtless, be simple to follow but they will almost certainly also advise that erecting the hut is a two person job. There's no point in getting halfway through and discovering that the experts were right all along. Two people will finish the job more quickly and easily than one. And once the hut is up, with the roof planks, tiles or roofing felt and trim pieces in place, the fun can really begin.

Your wooden hut is going to look pretty much like a garden shed or summerhouse when you finish building it, and it will certainly look out of place next to its gaily painted neighbours. To avoid your Cinderella hut feeling like it's turned up at the palace ball underdressed without the good fairy's magical gown, you need to roll up your sleeves and get on with the painting. Naturally, you will have to go through the whole process of priming or undercoating before you can apply the final topcoat, but the preparation will be worth it for a lasting finish. This is not simply a cosmetic measure. The wood on the walls, doors, window frames and shutters of your hut needs to be protected against the elements just as the bearers and floor are. In fact, the exterior of your hut has to be able to stand up to much harsher treatment. The sun will do its best to peel your paint away and it will be ably assisted by the wind that will whip up an abrasive cocktail of sand and small stones from the beach, blasting it against your paintwork. It is necessary, therefore, that your hut is repainted at least once a year and most local authorities insist on such regular maintenance, threatening the termination of the lease for those who let the condition of their huts deteriorate.

Most hutters, of course, take great pride in maintaining their huts. To devotees, a beach hut is more than just a garden shed on the sand, more even than a summerhouse or garden room. Keen gardeners may use their potting sheds as a retreat to escape for

Above: Why miss out on a fine English afternoon in the garden when you can bring most of it with you to your hut in Whitstable?

Opposite: Nothing looks as sad and lonely as a neglected, unloved beach hut. This one is at Dungeness in Kent.

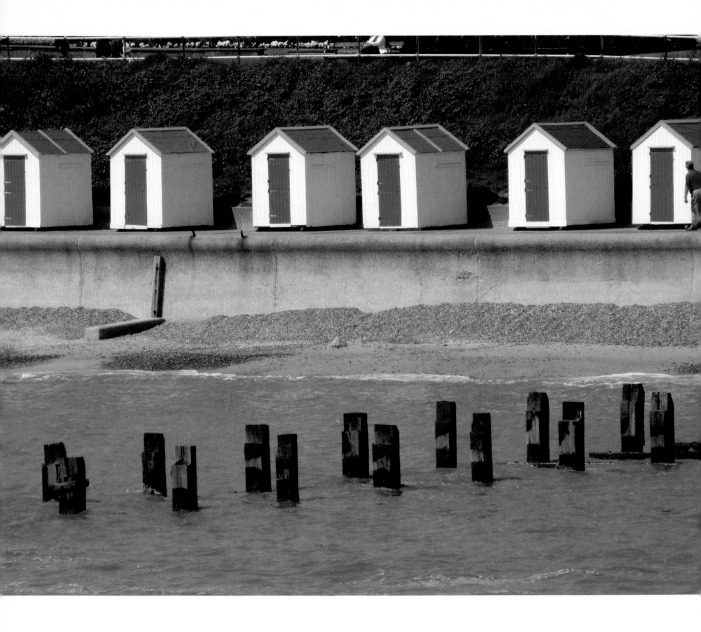

The blue beach hut doors stand like columns of sapphire on the sea wall at Southwold in England.

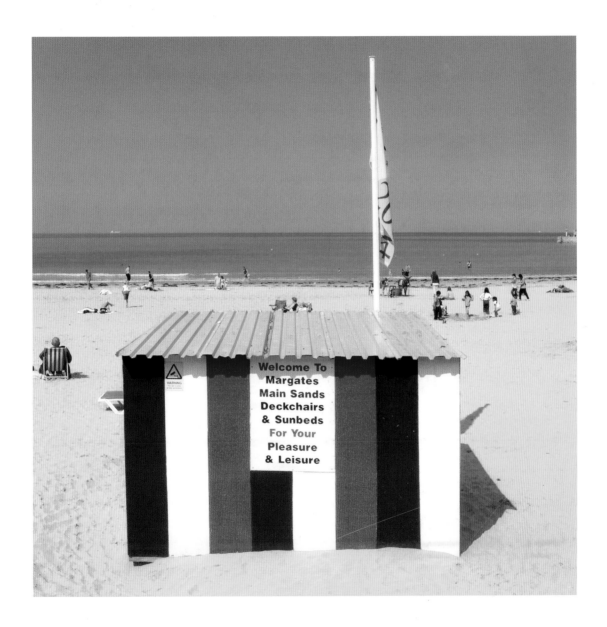

A rental hut practically guaranteeing pleasure and
leisure on the beach at Margate in England.

a few hours of solitary peace and quiet, but that's not the way that people view their beach hut retreats. The hut is for all the family to enjoy in a setting that is totally divorced from the house and garden at home. It's a base for enjoying a day at the beach, or a beach holiday if you can sleep overnight, and for socializing with neighbouring hutters. Spending a little time to keep your hut in top condition means that it will always be somewhere that you look forward to visiting, rather than a chore that is awaiting your attention. Painting the hut, then, is an essential job for protective, aesthetic and possibly psychological reasons, but it's a task that can be enjoyed. This is not, after all, like staining or treating a garden fence – no one had a favourite garden fence they like to visit at weekends – the idea is to make the hut look pretty.

There may well be regulatory restrictions on the colours you are allowed to use on the exterior of your hut; in some areas huts may only be painted white, but in others you can be as creative as you like. The hut's planks easily lend themselves to striped colour schemes but before you go completely Dali, check out your neighbours' huts. You don't want to upset your fellow hutters by creating something in day-glo green and purple that, however proud you might be of your efforts, everyone else sees as an eyesore. Remember, too, that the more complicated your paint scheme, the longer it will take to paint the next time. You should also bear in mind that the ironmongery of your hut needs to be protected just as much as the woodwork. Hinges, latches, locks and handles will all have to be carefully painted.

Even with the vast range of paint colours available, and even when given the freedom to use whatever colour takes their fancy, most hutters go for a shade that suits the location. This still gives ample scope for variety. Bright reds and yellows can suit a

seaside environment just as well as more subdued shades, reflecting the colours that are seen on the sails of boats and windsurfers, parasols and picnic blankets. The paintwork needn't simply be a functional affair, either. The huts at Wimereux in France have been given a nautical theme by adding motifs and embellishments to the basic paint scheme but if you don't feel confident enough to paint a rudimentary starfish, dolphin, or pirate ship freehand, you local DIY store will probably have stencils that will help get the job done. Such decorations are all part of the process of personalizing the hut, making your mark to show that this isn't just another beach hut – it's YOUR beach hut.

Beach huts will often be required to display a number so that the local authority can easily identify the owner, but that doesn't necessarily preclude hutters from giving their pride and joy a proper name as well. A name plaque above the door – anything from 'Pete's Place' and 'The Kennel' to 'Nirvana' and 'The Ritz' have been spotted – is another way of personalizing a hut, but the way that many owners choose to make their mark is on the insides of their huts.

The beach hut is a place not only to escape from the stresses and pressures of city living, but also somewhere to escape from the occasional spell of inclement weather at the coast. People who know they are going to spend time inside their hut make it as pleasant as possible. For those who use the hut only to squeeze themselves into a wetsuit before blasting off from the beach on a jet ski, the bare inside 'shed' walls may well be perfectly fine. A beach hut can, after all, be purely functional as opposed to a place of comfort. For those who use their beach hut as a day room by the sea, or who have a larger hut that serves as sleepover chalet accommodation, the appointment of the hut's interior is limited only by the imagination and, possibly, the depth of their pockets.

If all you want in your beach hut is a camping stove on which to boil a kettle or cook a rudimentary lunch, then there's little point in investing much time or effort on interior appointments. On the other hand, if you might like to while away the afternoon reading a book in the shade, or sheltering from the rain, you may as well do so in surroundings that are a cut above the bare planking of your hut walls. Huts will often come supplied with a bitumen or plastic liner on the walls to help keep out the worst of the weather. These can also, however, cause condensation inside the hut without proper ventilation if you are boiling a kettle — another source of damp that you can do without, so make sure you keep your door or windows open for a through-flow of air. Simply painting the bare walls or lining will give quite a spartan effect, but it is a simple enough job to clad the interior of the shed with wood panelling and some manufacturers will supply bespoke panelling kits to line their huts. Then you are in a position to varnish or paint the interior for a finish that will be far more pleasing on the eye than if you were to paint the bare walls.

While the colours that are used on the exterior of beach huts are many and varied, on the inside they are generally far less strident. A small, bright green or orange room isn't really the sort of place you would want to curl up with a good book. Soothing shades of pale blue, soft green or off-white are favourite — the colours of water. The lighter colours accentuate the natural light flooding into the hut through the open doors or windows and, even if the weather isn't conducive to sitting outside, give the overall feeling of tranquillity that people come to the coast to find. The soothing wash of the waves on the beach and the clean light of the seaside helps soothe away the stress of living in the fast (and none too clean) lane in a concrete city environment. In larger beach

huts which may have more than one room with sleeping quarters, light interior colours give a clean, healthy feel to the living space, bringing the outside light inside, bringing the outdoors indoors and promoting that uplifting feeling of going back to nature.

Not that you need go too far back to nature with a modern beach hut. Specifically designed accessories like water tanks and solar roof panels can provide fresh drinking water and power for lights or small electrical appliances, while with a gas stove and gas-powered fridge you can turn a humble hut into a luxury retreat that might even come close to rivalling one of those on a tropical beach in The Maldives.

To further promote the feeling that the beach hut can be used as a seaside hideaway or den, a few book shelves around the walls and a rug or sea-grass mat on the floor even in the smallest of huts is all many hutters need to make them feel snug inside while the weather is being uncooperative outside, but do take care about the way you line, panel or shelve your hut. Should the hut need to be taken down in order to be removed from the site during the winter months, as many local authorities insist, then attaching accoutrements to the interior walls might hamper the dismantling. They could also prove problematic when it comes to storing your hut. Walls that were delivered as flat packs will not fit neatly against each other for tidy storage when encumbered with shelving or other adornments. In some cases, where there is sufficient access, it might be possible to have your hut lifted off your pitch intact and taken off for storage on the back of a truck in much the same way that an illegally parked car is hoisted onto the back of a tow truck and whisked away. Somehow, though, that concept seems at odds with the spirit of the beach hut. It is far more fitting that huts that must be removed each year should wilt in the autumn like fading flowers and rise again in the spring as new blooms.

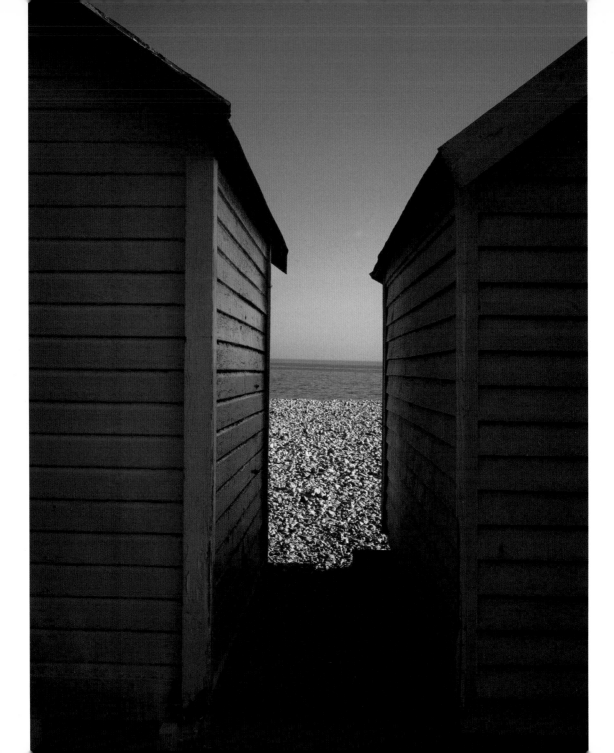

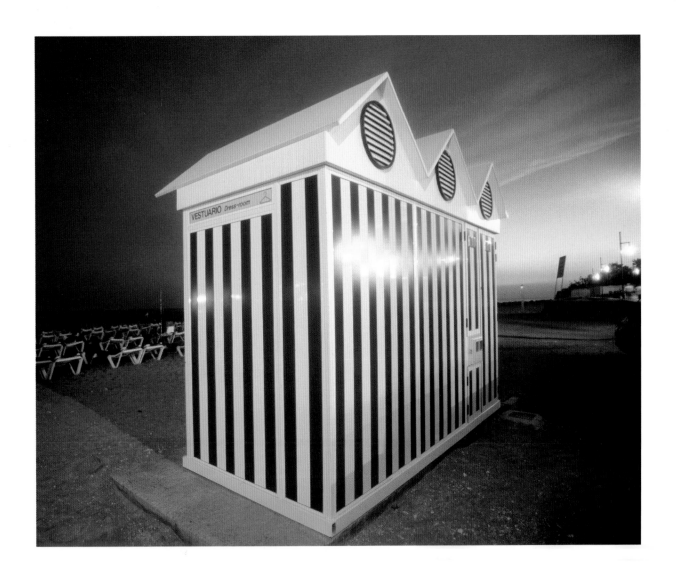

Above: This bold design captures the colour of the Canary Islands,
on one of the many beaches on the holiday island of Tenerife.
Opposite: A glimpse of the sea from between the huts on the shore
at the English resort of Lyme Regis in Dorset.

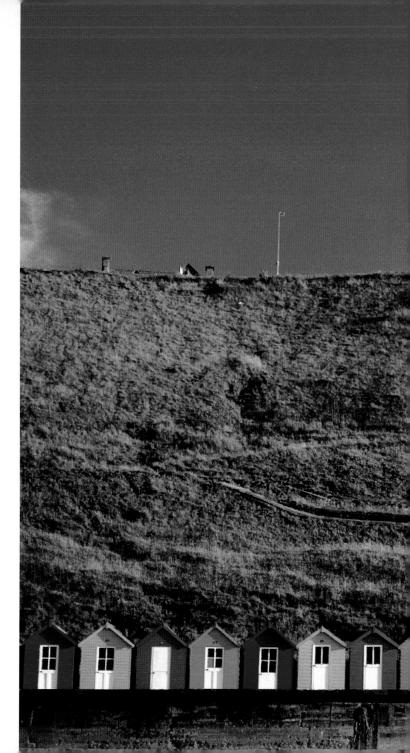

This cheerful array of English beach huts seems rather at odds with the gloomy mansion atop the cliff in Whitby – but then, this was the place where Dracula's coffin came ashore!

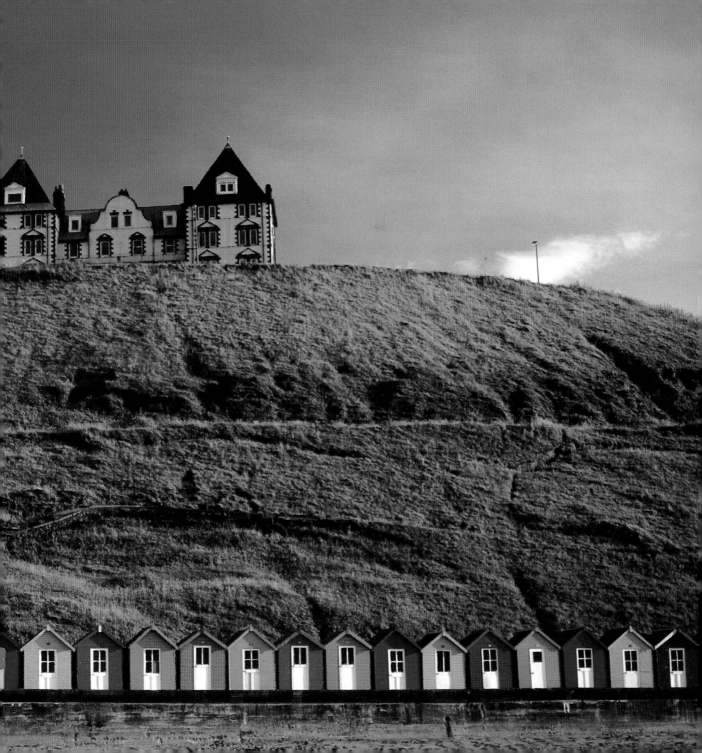

The stark shapes of beach hut rooflines frame the summer sky in a pleasing manner when viewed from a relaxed position in a deck chair.

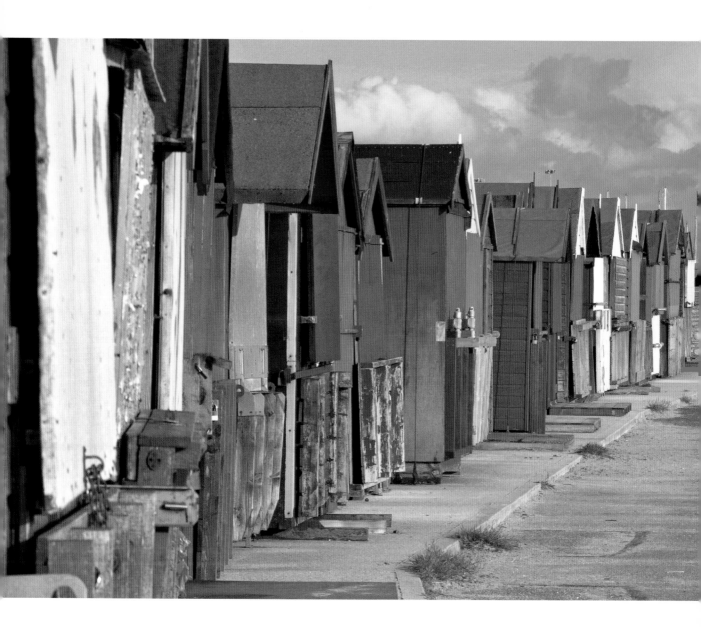

With their front decks drawn up and shutters bolted, these sleepy Dorset huts
are awakening to the start of another glorious English summer's day.

People who take care of their beach huts are not only protecting a family asset, a base from which to enjoy life at the beach for many years to come, they are preserving a much admired feature of the seaside resort (whether they do so purposely or not) that has become a tourist attraction in its own right. They are also ensuring that a historical seaside tradition stretching back to the 19th century is kept alive and well in the 21st century not only on the beaches around the British coast, but in France, Italy and right around the world to South Africa and Australia – so keep applying the paint and Happy Hutting!

Blackpool Tower may be the most famous building in the ever-popular English resort, but if you want a cappuccino in the sunshine, this cafe hut is the place for you.

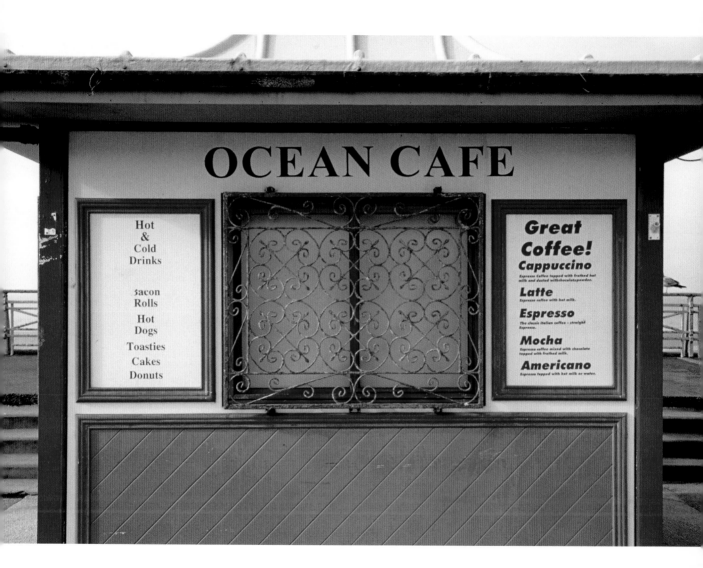

OCEAN CAFE

Hot
&
Cold
Drinks

Bacon
Rolls

Hot
Dogs

Toasties

Cakes
Donuts

**Great Coffee!**

**Cappuccino**
Espresso Coffee topped with frothed hot milk and dusted with chocolate powder.

**Latte**
Espresso coffee with hot milk.

**Espresso**
The classic Italian coffee - straight Espresso.

**Mocha**
Espresso coffee mixed with chocolate topped with frothed milk.

**Americano**
Espresso topped with hot milk or water.

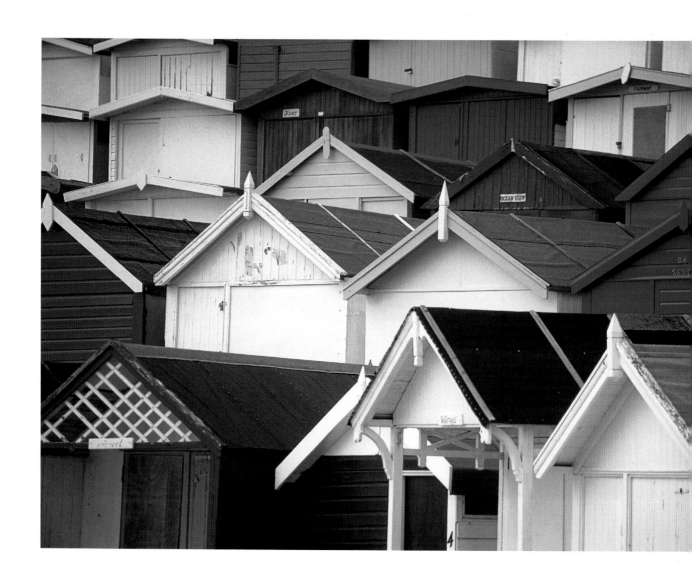

Like a shanty town climbing the hillside, these huts in Essex, England,
seem to huddle together for comfort and companionship.

Strolling along this avenue of beach hut decks, you could be forgiven for thinking
you were the local sheriff pacing the boardwalk in the wild west.

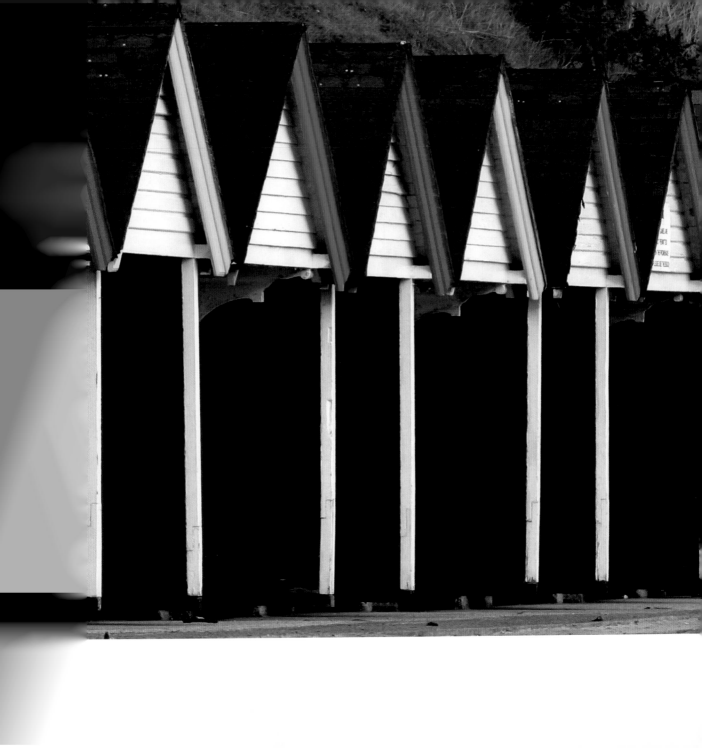

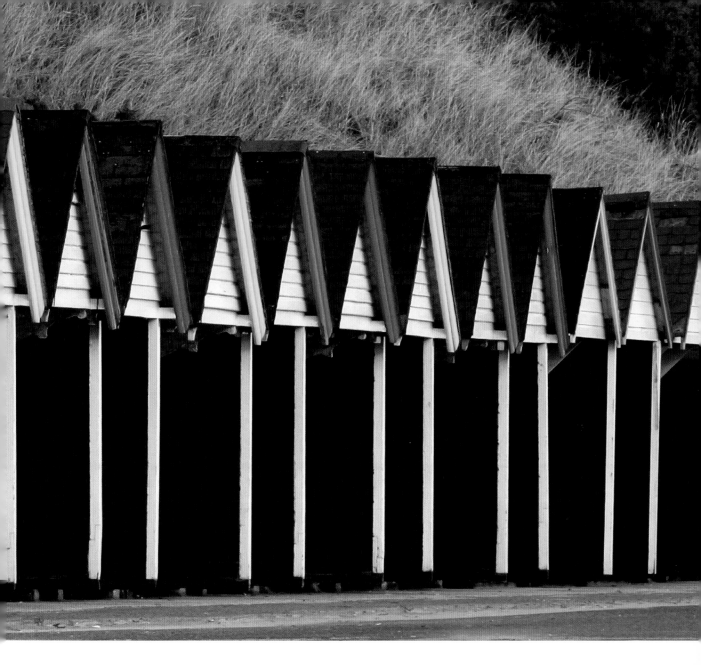

Like sombre Victorian English ladies hitching up their skirts, these soberly attired Bournemouth huts show a flirtatious flash of their frivolously coloured undergarments.

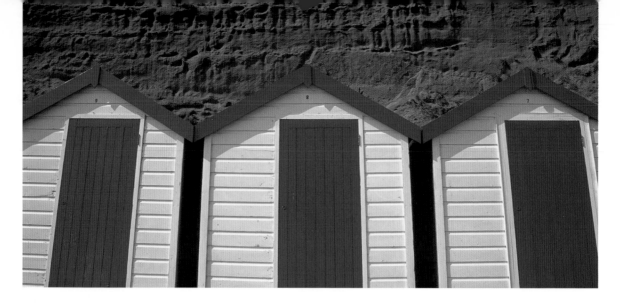

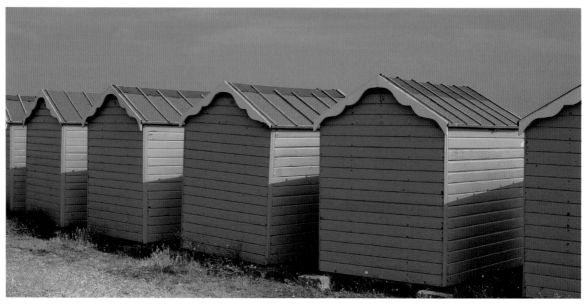

Top: These sentry-box huts at Sandown on the Isle of Wight in England stand to attention in immaculate blue and white uniforms.
Above: The swirling yellow of their roof fascia boards rescue these huts at Littlehampton in England from a sulky blue mood.

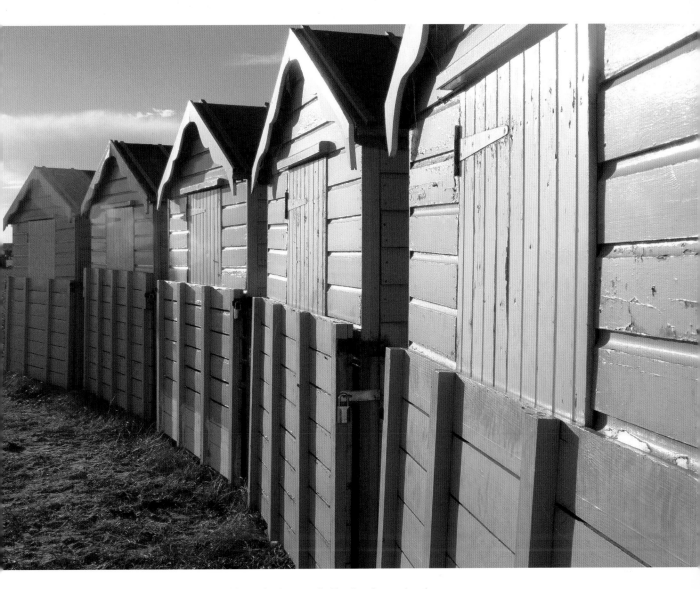

The front decks of some huts, like these in Sussex in England, can be drawn
up and padlocked across the door at night for extra security.

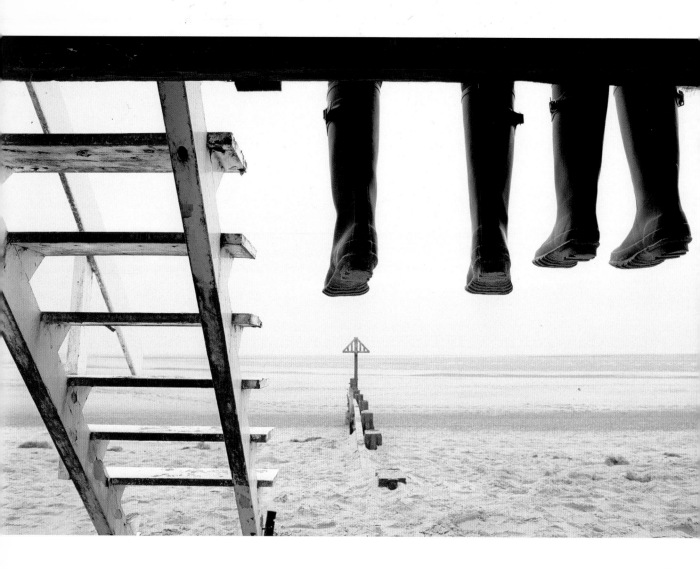

If it's a day when you need boots on the beach, you might
also be glad of the shelter your hut can provide.

# INDEX

PICTURE CREDITS:

Alamy/Rubens Abboud 101; /Peter Adams Photography 78; /Agence Images/DR-IAP 4; /David Burton 59; Joe Cornish/Arcaid 74-75; /Steve Atkins 11; /Pat Behnke 129; /Michael Booth 14; /Jon Bower 97; /Paul Bradforth 133; /Nina Buesing 104 bottom right; /Paul Hardy Carter 109; /Frank Chmura 87 bottom; /Joe Devenney 32; /Mark Dyball 104 top left; /Tracey Fahy 27; /Juliet Ferguson 128; /Malcolm Freeman 19, 62; /Mark Fremaux 77 left; /geophotos 52-53; /June Green 44-45; /Stephen Griffin/Eye Ubiquitous 136; /Tracy Hallett 43; /Mark Hamilton 69, 132; /Robert Harding Picture Library Ltd. 46, 112; /Nigel Hicks 12; /Esa Hitula 31; /David Martyn Hughes 120; /David Martyn Hughes/Images-of-France 85, 111; /image100 142; /Imagestopshop 84; /ISP Photography 63; /Michael Jenner 140 top; /Sam Jones 72; /Mike Kipling 130-131; /Julius Lando 68; /www.janelewis.co.uk 137; /Tony Lilley 58; /David Martyn Hughes 18; /Mediacolor's 87 top; /Robert Morris 13, 33; /David Newham 24; /Roger Overall 94, 100; /PCL 107; /Les Polders 114; /Popperfoto 22; /Ben Ramos 55; /Gary Roebuck 2, 141; /John Rose 138-139; /Gerald Schwabe/F1 online 8-9/; Vicky Skeet 42; /Trevor Smithers ARPS 73; /Jack Sparticus 86; /David Stares 23; /Robin Steward 135; /Adam Tiernan Thomas 54; /Peter Titmuss 113; /David Trevor 30; /Richard W. Turner 10; /Colin Walton 140 bottom; Paul Watson/Travel Ink 37; /Tony Watson 121; /Kevin White 123; /Kathy Wright 122
Corbis UK Ltd/Bettmann 110; /Todd Gipstein 76; /Jon Hicks 77 right; /Charles O'Rear 105

The publishers also wish to thank:

Michelle Pickering, Sue Bosanko and Jennifer Veall for their hard work.

Cover design: Auberon Hedgecoe